INTRODUCTION TO PENCIL TECHNIQUES

鉛筆畫技法

三澤寬志

發行／北星圖書事業股份有限公司

目錄

CONTENTS

前言

Foreward

 即使只有一枝鉛筆，也可因使用方式之不同，而有多樣化的表現。你可以用複雜的手法畫出工筆畫，也可以用簡單的線條畫出事物的形狀。本書將以淺顯的圖解及實例說明其鉛筆素描的基本方法。它將有助於任何想用鉛筆從事繪畫創作或插圖的人。

Depending on how it is used, a single pencil may be used to create a numerous expressions. Complicated shading can be added to produce a realistic rendering of subject or a few simple lines can be used to grasp the shape of the subject. This book uses diagrams and examples to explain the basic techniques employed in pencil drawing and it will be useful to anyone interested in creating sketches for painting, design or illustration.

第 1 章
如何使用鉛筆

Chapter 1

Using Pencils

鉛筆素描

Drawing with Pencils

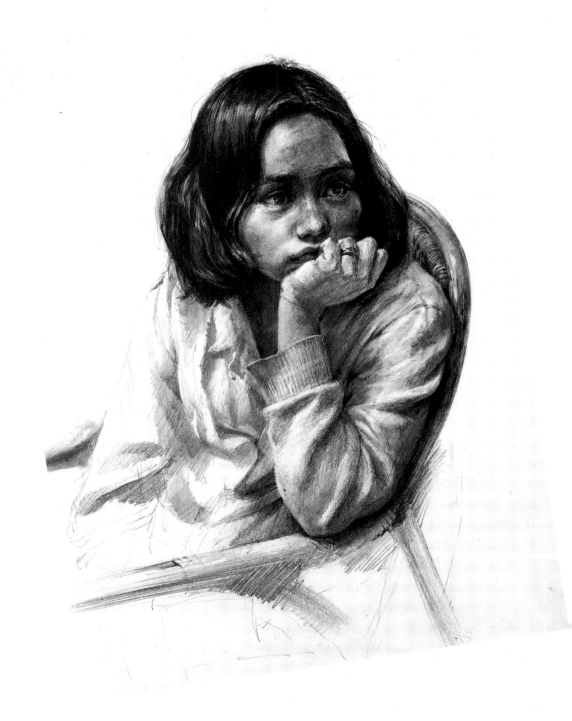

費時而仔細描繪的精細作品。　　　　　　Time has been taken to create a detailed drawing.

鉛筆是可以巧妙掌握線條的強弱和明暗的通俗畫具，廣泛用於畫家和設計師之間。因爲從草圖到精緻的創作，它都可以表現得很好，所以也是基礎設計的繪畫訓練最好的畫材。

The pencil is a medium which offers delicate control over shading or the density of lines and is commonly used by both artists and designers. It can be used for a wide range of expression from rough sketching to fine drawing and is the ideal medium when creating the basic sketch for a painting.

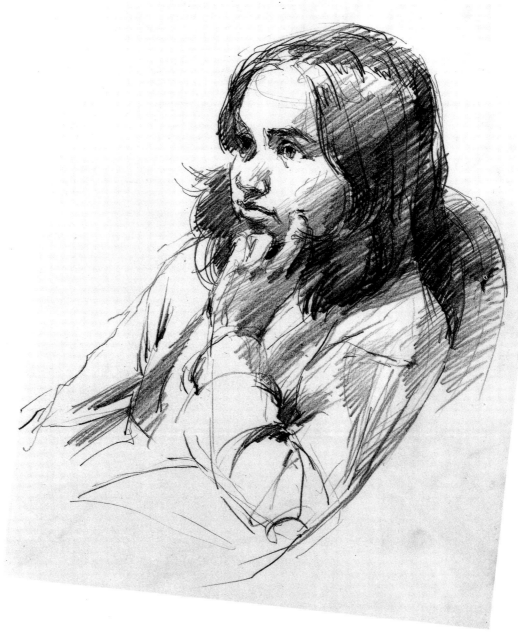

在短時間內畫出的素描草圖。

A rough sketch can be completed in a very short time.

如何削鉛筆

Sharpening a Pencil

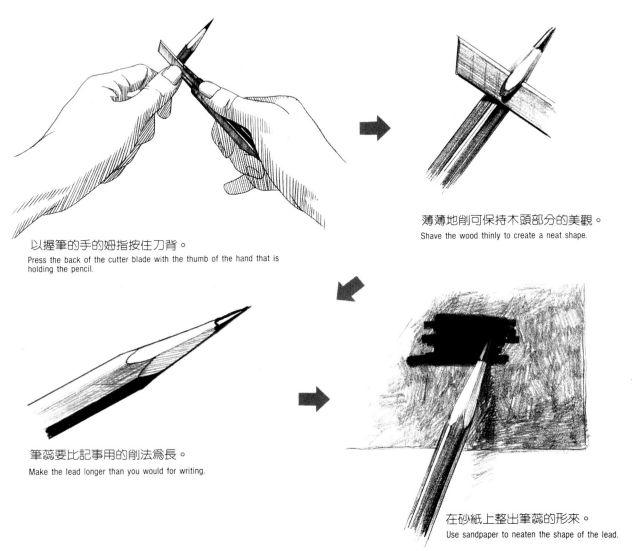

以握筆的手的姆指按住刀背。

Press the back of the cutter blade with the thumb of the hand that is holding the pencil.

薄薄地削可保持木頭部分的美觀。

Shave the wood thinly to create a neat shape.

筆蕊要比記事用的削法為長。

Make the lead longer than you would for writing.

在砂紙上整出筆蕊的形來。

Use sandpaper to neaten the shape of the lead.

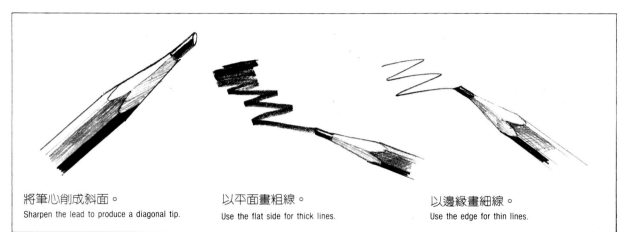

將筆心削成斜面。

Sharpen the lead to produce a diagonal tip.

以平面畫粗線。

Use the flat side for thick lines.

以邊緣畫細線。

Use the edge for thin lines.

在素描的時候，鉛筆有豎立、打斜，或強壓等不同的使用方式，因此，筆蕊要留得比記事用的筆蕊長，才方便使用。

When drawing a sketch the pencil is used in a variety of ways, utilizing both the tip and the side of the lead as well as applying varying pressure so when sharpening it is useful to make the lead longer than you would for writing.

豎立鉛筆，用筆尖來畫。

Hold the pencil vertically and draw with the tip of the lead.

將鉛筆打斜，用筆蕊的側面來畫。

Hold the pencil at an angle to the paper and use the side of the lead.

如何握筆

Holding the Pencil

爲能自在掌握線條的強弱和明暗，必須變換不同的握筆方式，如：握住尖端，長而輕地握住，或是對筆蕊施壓等。

In order to control the density of the lines or shading fully, it is necessary to alter the way in which the pencil is held, holding it at the tip, loosely at the end or pressing down on the lead itself.

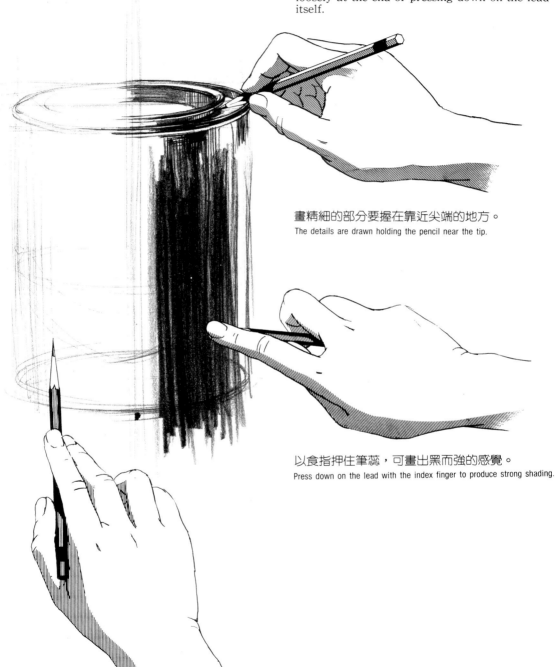

畫精細的部分要握在靠近尖端的地方。
The details are drawn holding the pencil near the tip.

以食指押住筆蕊，可畫出黑而強的感覺。
Press down on the lead with the index finger to produce strong shading.

輕輕地握住筆的尾端，可畫出淺而粗略的線條或氣氛。
Hold the pencil lightly at the end to produce rough, light lines or shading.

鉛筆太短時，可加裝助握器。
When a pencil becomes too short, it can be placed in a holder.

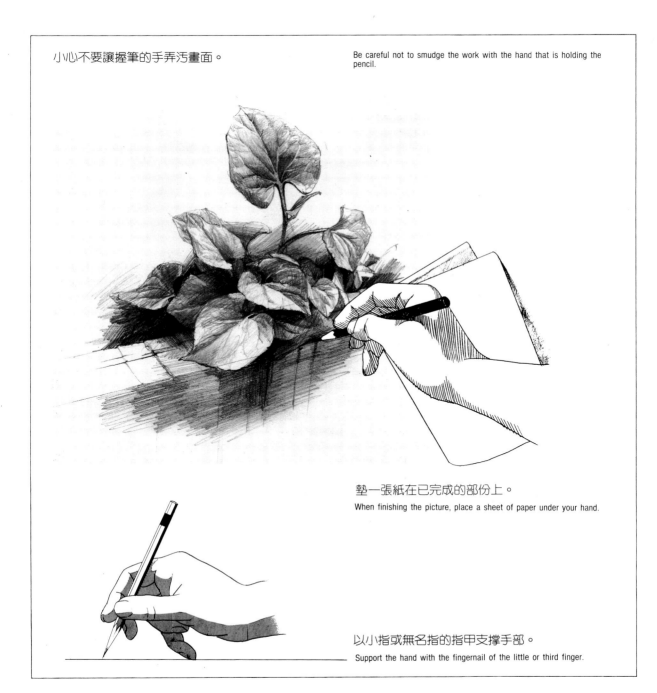

小心不要讓握筆的手弄污畫面。

Be careful not to smudge the work with the hand that is holding the pencil.

墊一張紙在已完成的部份上。
When finishing the picture, place a sheet of paper under your hand.

以小指或無名指的指甲支撐手部。
Support the hand with the fingernail of the little or third finger.

硬蕊與軟蕊

Hard Pencils and Soft Pencils

鉛筆有硬蕊和軟蕊之分。硬的以H表示，軟的以B來表示。在其前方所記之數字大小，與其軟硬度成正比。F和HB則是介於H和B之間的硬度。各種作品所需之硬度不同，但若能將硬、軟及中度的筆各準備一枝，也就夠用了。

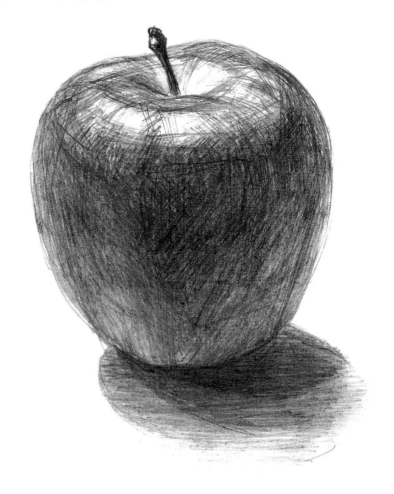

只有用２Ｈ畫出的圖。硬筆的粒子較細，濃度較淡。

A sketch produced using only a 2H pencil. With a hard pencil, the particles of lead are very fine and the color is weak.

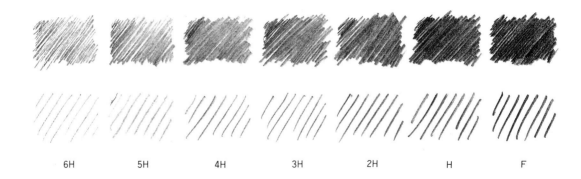

| 6H | 5H | 4H | 3H | 2H | H | F |

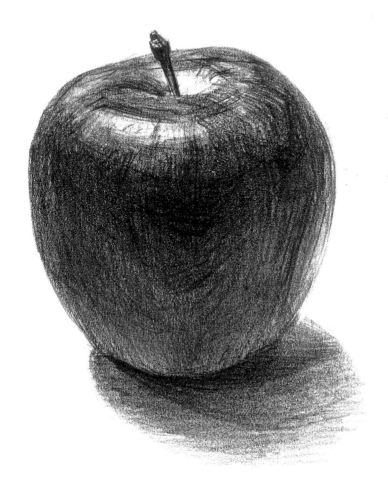

Pencils can be divided into two groups, those with hard leads and those with soft leads. Hard leads are designated by the letter H and soft leads by the letter B. The higher the number in front of the letter, the harder or softer the lead. F and HB are midtones between H and B. The hardness of the leads varies somewhat between manufacturers but you should be able to express a majority of subjects if you have one hard, one soft and one mid-tone pencil.

只用２Ｂ畫出的畫。軟蕊的粒子粗而濃度濃。

A sketch produced using only a 2B pencil. With a soft pencil, the particles of lead are large and the color is denser.

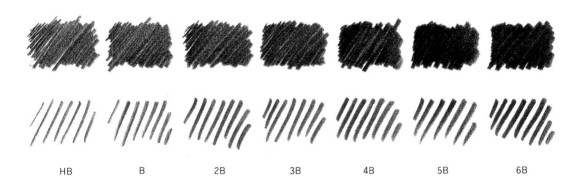

| HB | B | 2B | 3B | 4B | 5B | 6B |

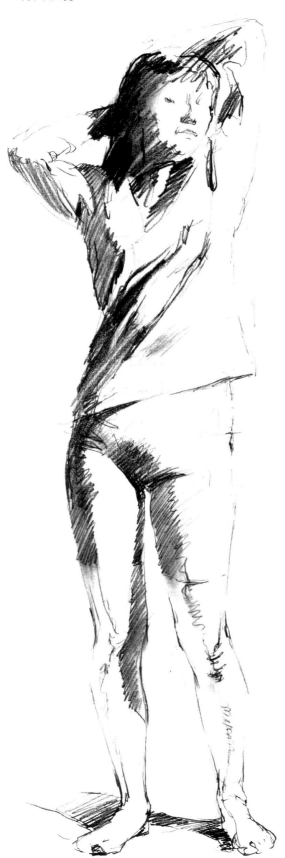

用軟蕊筆素描

　　即使只有一枝鉛筆，也可靠筆壓的強弱或筆，觸的重疊畫出寬幅的明暗表現。2B左右的軟心筆較容易控制明暗的濃淡。

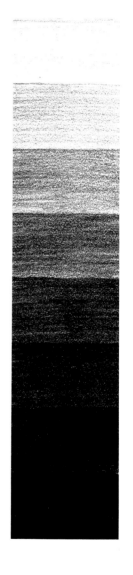

只用一枝2B鉛筆所畫的素描。

A sketch produced using a single 2B pencil.

Drawing with a Soft Pencil

By controlling the pressure, and building up the shading a wide range of expression may be achieved using a single pencil. It is comparatively easy to control the depth of tone if a soft pencil like a 2B is used.

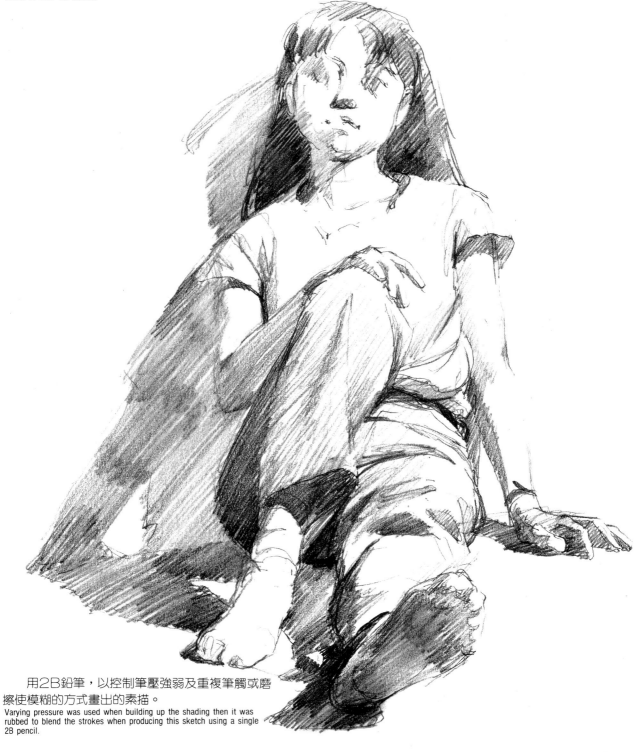

用2B鉛筆，以控制筆壓強弱及重複筆觸或磨擦使模糊的方式畫出的素描。

Varying pressure was used when building up the shading then it was rubbed to blend the strokes when producing this sketch using a single 2B pencil.

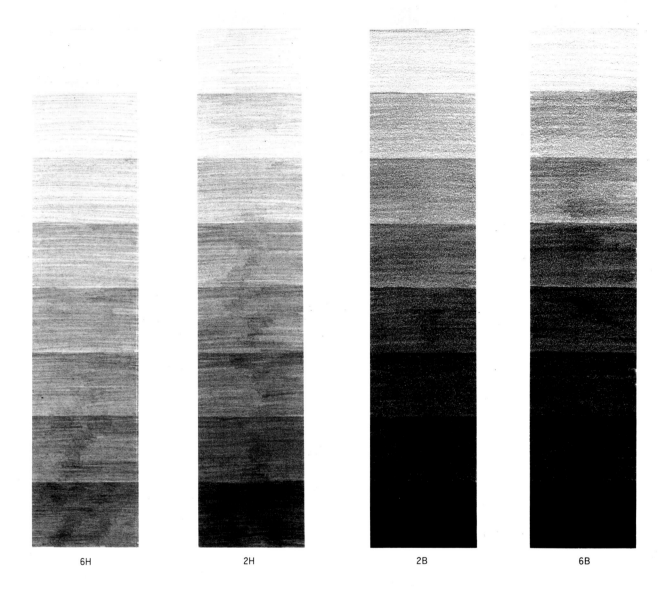

6H 2H 2B 6B

以壓平鉛筆所畫出的9種不同的明暗度。較亮者筆壓較弱，而愈暗則筆壓愈強。

Nine tones of shading produced using the side of tones are produced using the lead. The light minimal pressure while the dark tones are produced using progressively stronger pressure when building up.

區分利用鉛筆的軟硬度

　　就像較硬的質材要用硬筆，而很黑的東西要用軟筆來畫一般，試著區分利用鉛筆的軟硬度在一幅作品中表現出對象物的質感，固有色，或是明暗。

Appropriate Use of Hard and Soft Pencils

A hard pencil should be used to express the texture of hard objects while a soft pencil is used to express dark objects. In this way different pencils should be used to express the various textures, colors and tones that occur within a single sketch. While it is important to master the use of a single pencil, one should also learn the appropriate use of the various leads to produce an accurate sketch.

亮的部分用硬的H。
The bright edge uses a slightly hard H pencil.

粗糙的部分用5B。
The rough shading uses a 5B.

背面的陰暗處以4B磨擦。
The dark shading in the shadow uses a 4B that has been rubbed in.

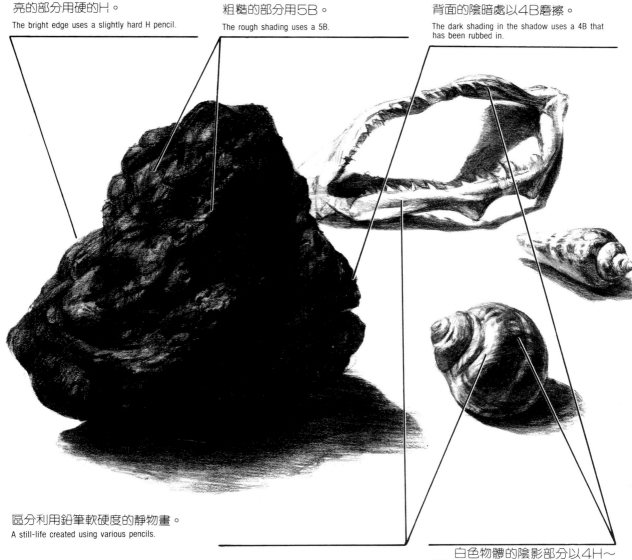

區分利用鉛筆軟硬度的靜物畫。
A still-life created using various pencils.

白色物體的明亮部分以B輕描。
The bright edge on the white objects uses a tone added lightly with a B.

白色物體的陰影部分以4H～2H摩出暗度。
The shadow on the white objects uses shading with a 4H—2H that has been blended through rubbing.

如何選擇用紙

Choosing Paper

　　紋理的、疏密和纖維的硬度可形成不同種類的紙。要畫精緻的畫,就要選用較密而硬的紙。通常草圖用薄紙即可,但若想利用粗紙本身的紋理時也可自由選擇配合。

There are numerous types of paper of varying textures and hardness. A paper with a fine texture that is made of hard fibres is suitable when work calls for fine detail. Thin paper is adequate for a rough sketch but one should also think about he wants to achieve, for instance, the expression might benefit from the use of textured paper.

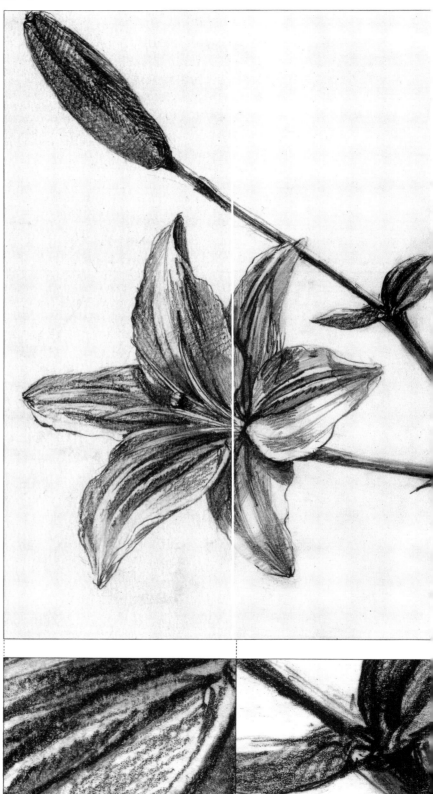

圖畫紙　Drawing Paper　　　　肯特紙　Kent Paper

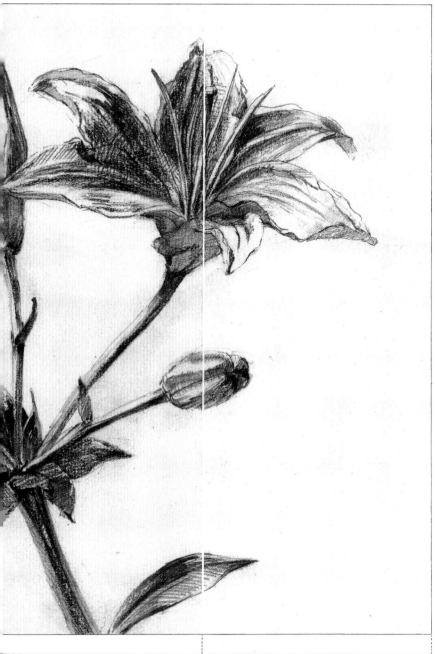

圖畫紙：鉛筆粒子的附著力佳
，很容易廣泛地繪由白到黑的明暗
度，適用於基礎素描。

肯特紙：紋理較細，適合表現
精密的線條。

棉紙和水彩紙：紋理較粗，適
合表現獨特的質感。

Drawing Paper: The particles of graphite adhere to the paper well making it easy to produce a wide range of tones from white to black. It is ideal for basic sketching.
Kent Paper: The texture is very smooth making it ideal for sharp lines and detailed work.
Cotton Paper and Watercolor Paper: The rougher the texture, the more unique the resulting sketch becomes.

棉紙　　Cotton Paper　　　水彩紙　Watercolor Paper

寫生簿

　　包含圖畫紙及水彩紙等各種厚紙的簿子適合長時間的素描。而包含高等紙及中等紙等薄紙的簿子適合短時間的素描。

Sketchbook

Sketchbooks can contain Drawing paper or Watercolor paper for sketches that require a lot of time while thinner high to medium quality paper are available for quick sketches.

坐在椅子上畫。

Sitting down to sketch.

站著畫。

Standing up to sketch.

畫板

當你預備長時間寫生時，可利用畫板，以夾子或圖釘來固定圖畫紙或肯特紙。

Panel

When you plan to spend a long time on a sketch it is a good idea to affix a sheet of Drawing or Kent paper to a panel with clips or drawing pins.

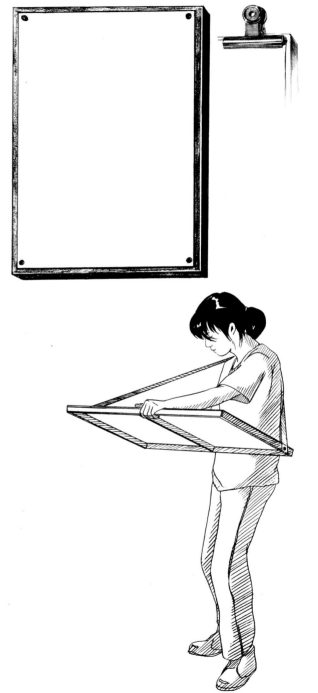

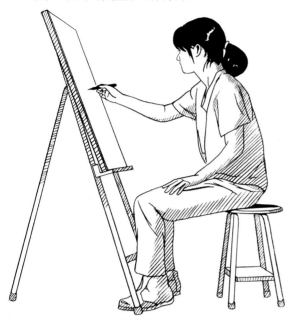

把畫板架在畫架上，可以看見整幅畫，也很方便握筆的手移動。

If the panel is set on an easel the whole sketch can be seen at a glance and it is easy to work with the pencils.

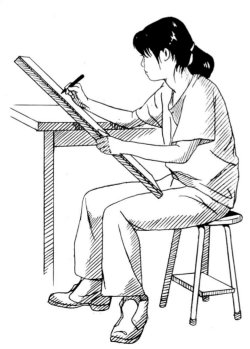

把畫板靠在桌邊，可以畫桌上的主題。

A panel can be leaned against the edge of a table when working on a tabletop still-life.

在畫板上掛條繩子，可方便站立作畫。

A cord may be attached to the edge of the panel to make it easy to work standing up.

橡皮擦與可揉捏橡皮擦

Plastic Erasers and Kneadable Erasers

一般定型橡皮擦
Plastic Erasers

用於清潔畫面，或修正超出的部分或完成畫作時。

These are used for cleaning the paper, erasing shading that has extended beyond an outline or for finishing a picture.

用刀片切割，使邊緣尖銳。一但弄髒或邊緣變圓就要再度切割。

Use a cutter to produce a sharp edge.
Sharpen the edge. If it becomes dirty or rounded, cut it again to produce a new surface.

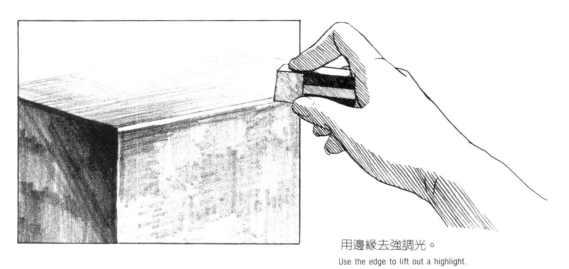

用邊緣去強調光。

Use the edge to lift out a highlight.

使用時要有護套。　Use with masking：

加上全幅的陰影。

1. Add the overall shading.

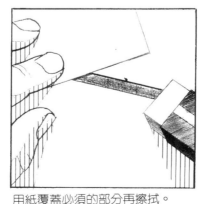

用紙覆蓋必須的部分再擦拭。

2. Cover the necessary areas with paper.

明亮的部分可以表現得很俐落。

3. The light area can be expressed sharply.

22

可揉捏橡皮擦
Kneadable Erasers

可揉捏橡皮擦常被用於調和明暗度。

A kneadable eraser is used more for adjusting the tones than for erasing.

用手指捏成方便使用的形狀。髒了就把乾淨的部分捏出來再用。

Knead with the fingers to produce the required shape. If the surface becomes dirty, knead it to produce a clean surface.

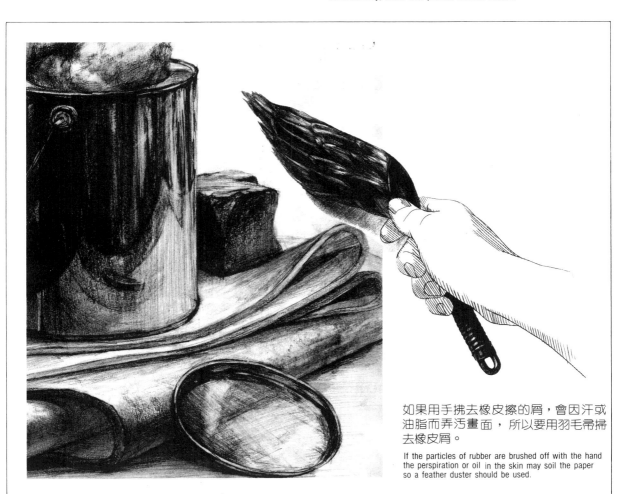

如果用手拂去橡皮擦的屑，會因汗或油脂而弄污畫面，所以要用羽毛帚掃去橡皮屑。

If the particles of rubber are brushed off with the hand the perspiration or oil in the skin may soil the paper so a feather duster should be used.

如何保護畫面

Protecting the Surface of the Picture

鉛筆畫的表面只要有些許磨擦便會弄髒。為了要保護畫面，便要在完成的作品上噴灑定型液。

If the surface of a pencil sketch is rubbed lightly it will become soiled. For this reason, once the picture has been completed, it should be sprayed with a coat of fixative.

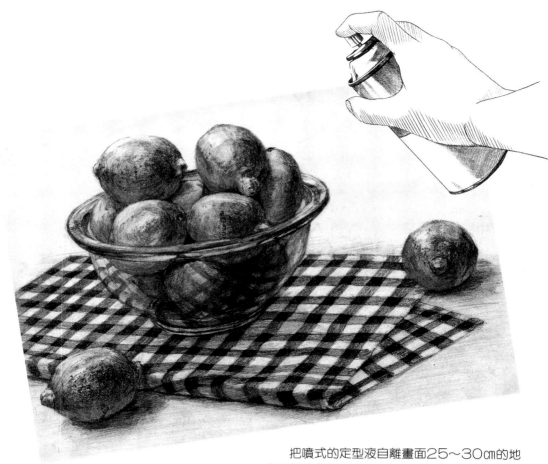

把噴式的定型液自離畫面25～30㎝的地方均勻噴在整幅畫上。

When using spray-type fixative, the can should be held approximately 25-30 cm. from the paper in order to apply an even coat.

第 2 章
如何表現形體

Chapter 2
How to Express the Shape

如何構圖
Grasping the Basic Shape

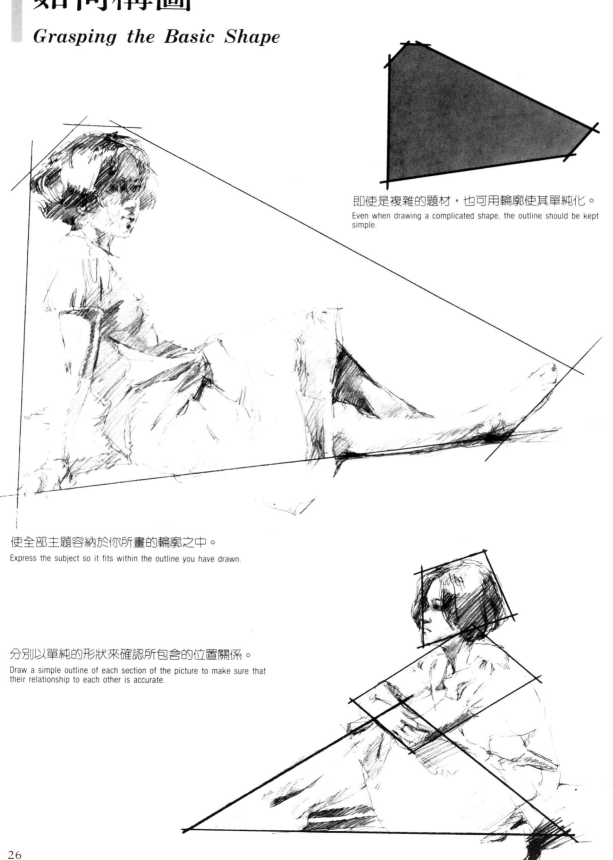

即使是複雜的題材，也可用輪廓使其單純化。

Even when drawing a complicated shape, the outline should be kept simple.

使全部主題容納於你所畫的輪廓之中。

Express the subject so it fits within the outline you have drawn.

分別以單純的形狀來確認所包含的位置關係。

Draw a simple outline of each section of the picture to make sure that their relationship to each other is accurate.

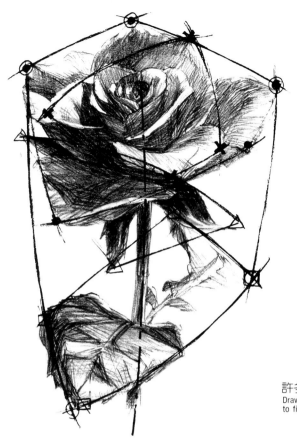

用輪廓線來確認
Draw an Outline to Check the Shape

　　用線條包住整個主題或是部分的形體，使其變成簡單的形狀後，便可掌握細部或整體的形狀了。在畫面上輕輕畫線以確認整體的形狀。

Start by drawing a simple line around the motif or around a part of it and this will allow you to grasp the shape without becoming caught up with the details. Draw the line faintly on the paper and check the shape.

　　用有弧度的線來畫輪廓，你將發現一個主題會有許多線條。

Draw the outline of the subject using curved lines. You should be able to find numerous lines in a single subject.

節奏線
Rhythmic Lines

用弧狀的曲線來捕捉主題的韻律感。

Grasp the rhythmic flow of the subject using curved lines.

把線的重疊、長度和圓弧的變化當作一種韻律、節奏來捕捉。

Build up the lines, altering their length and curvature to catch the rhythm of the subject.

包圍複數的題材

　　用線包圍來確認形狀的方法也適用於有複數主題的場合。透過數條線的描畫便可確定形狀與位置的關係。

Outlining Numerous Subjects

The technique of drawing an outline to check the shape of a subject is effective for multiple subjects too. By drawing several outlines, it is possible to check both the shape and relationship between each object.

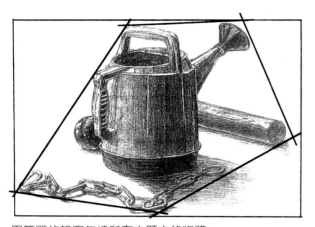

用簡單的輪廓包括所有主題中的物體。

Draw a single outline enclosing all of the objects in the motif.

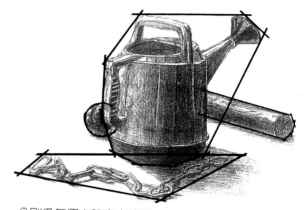

分別為每個主體畫出輪廓。

Draw an outline of each object.

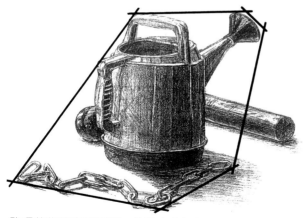

許多的物體也可用單一的輪廓來包括。

Several objects may be enclosed within a single outline.

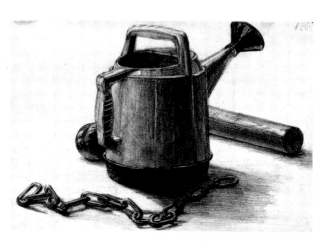

延長直線
Extending Straight Lines

延長題材某部分的線以確定其位置之正確性。

The lines of the subject can be extended to check the accuracy of their position.

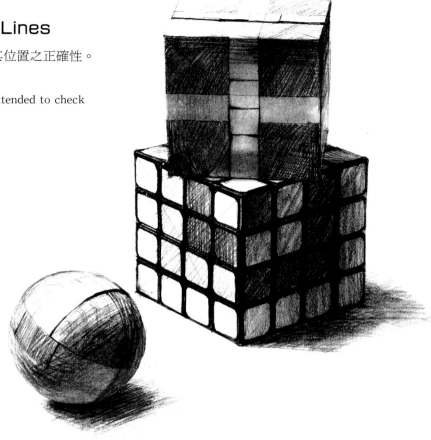

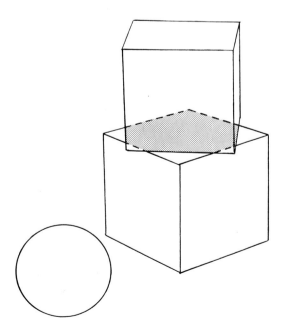

延長線條來確認其相關位置和形狀。
Extend a straight line to check what lies in its path.

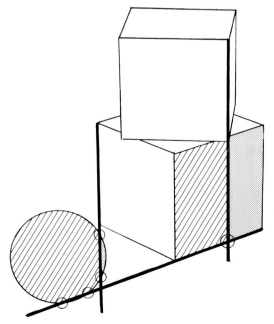

延長直線來確定它會經過哪些部分。
Extend a hidden line to check its position and relationship with others.

29

描繪正確的形狀
Expressing the Shape Accurately

測量比例
Measure the Ratio

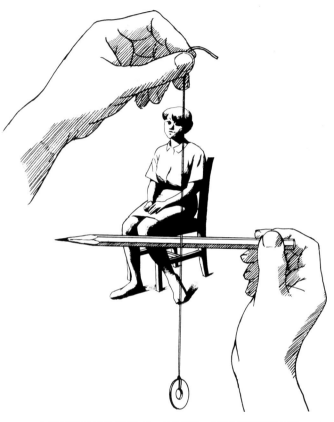

以垂掛重量之繩構成一垂直線，再用鉛筆與其直角來測量水平。

Use a weight on a string to get a vertical line. A pencil held at right-angles to this will provide a horizontal.

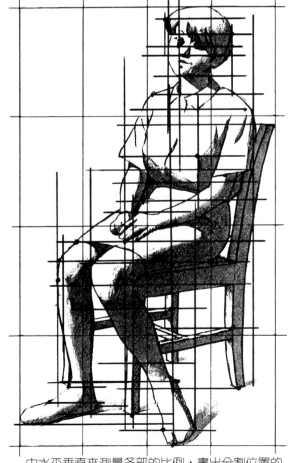

由水平垂直來測量各部的比例，畫出分割位置的畫面。

Use the vertical and horizontal lines to measure the ratio between the various parts and transfer them to the paper.

以水平線和垂直線為基準，測量縱橫的比例、分割出正確的位置關係。此方法將可掌握物體的立體感，在畫面上呈現出正確的比例。

Use vertical and horizontal lines to compute the accurate positioning of the subject. In this way you can create accurate ratios within the picture without being confused by the depth of the subject.

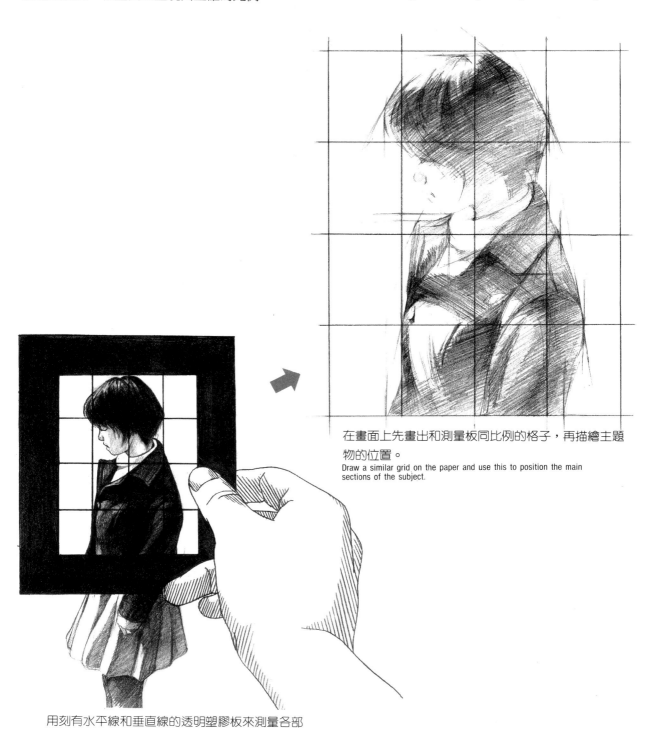

在畫面上先畫出和測量板同比例的格子，再描繪主題物的位置。

Draw a similar grid on the paper and use this to position the main sections of the subject.

用刻有水平線和垂直線的透明塑膠板來測量各部位的關係。

Use a grid on a sheet of transparent plastic to check the relative positions of the various parts of the subject.

測量棒的使用法
Using a Measuring Rod

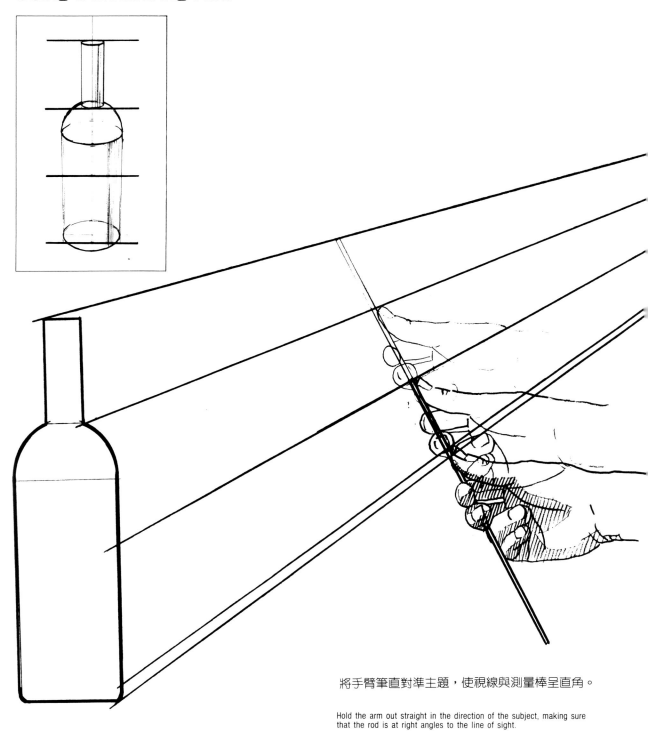

將手臂筆直對準主題，使視線與測量棒呈直角。

Hold the arm out straight in the direction of the subject, making sure that the rod is at right angles to the line of sight.

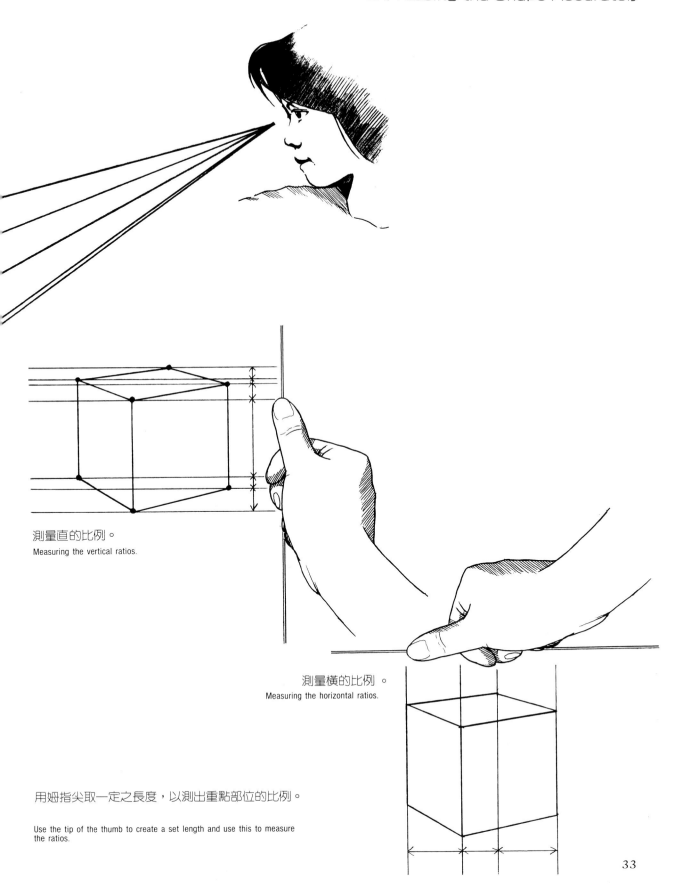

測量直的比例。

Measuring the vertical ratios.

測量橫的比例。

Measuring the horizontal ratios.

用姆指尖取一定之長度，以測出重點部位的比例。

Use the tip of the thumb to create a set length and use this to measure the ratios.

如何表現立體感

Creating an Expression of Depth

捕捉結構線

幾乎所有的工業製品都可分爲結構箱與結構軸。
了解結構將有助於捉住題材的立體感。

Grasp the Structural Lines

The majority of manufactured objects can be
broken down into box or cylindrical structures and
an understanding of this is very useful when
creating a three-dimensional expression.

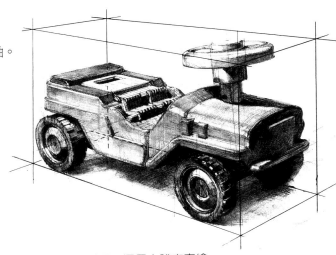

將全部題材用一個長方體來容繪。

Grasp the whole subject as a single rectangular box.

再由此箱形削繪出物體的形狀。

Pick out the actual shape of the subject from within the box.

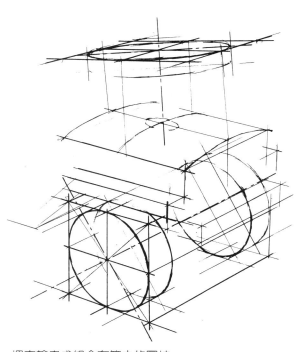

把車輪畫成組合在箱中的圓柱。

Grasp the wheels as cylinders that are located inside the box and
combine them with the basic shape.

把形狀畫得像一疊箱子。

Grasp the shape as a pile of boxes.

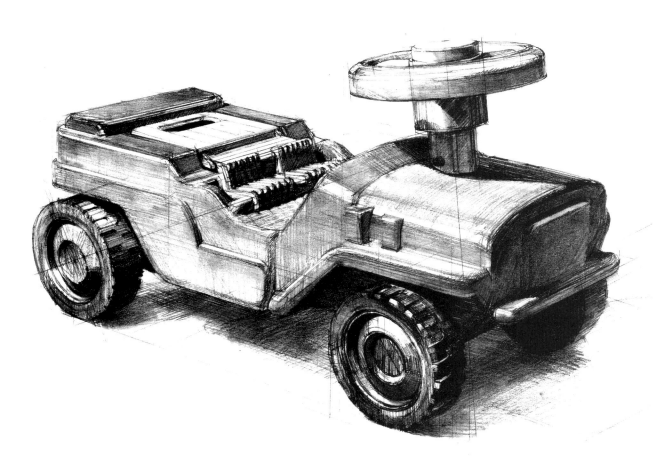

削去箱形的某部分，便可創造出角的面來。

Areas of the block may be shaved down to create the curved corners.

1.箱形先描出來

1. First draw the block.

2.畫新的表面。

2. Draw a new surface.

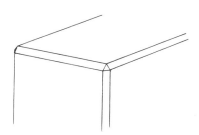

3.擦掉角，就剩下面了。

3. Erase the corner, leaving the surface.

畫出有結構性的圖
Grasp the Structural Formation

看在中心軸上加上橢圓的方式。

Look at the formation of the ovals around the central axis.

把零件的附加方法也想成簡單形狀的組合。

Think of the combination of the parts as simple shapes.

中心軸　The central axis.

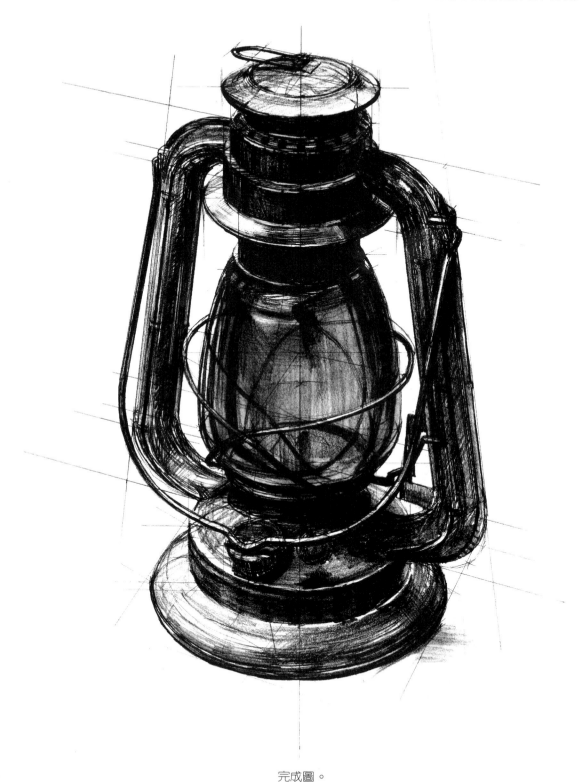

完成圖。

The finished drawing

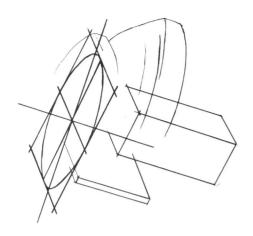

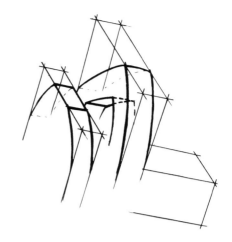

以箱型及圓盤型組合。

The shape is grasped as a combination of boxes and circles.

將箱型削去以求得所要的形狀。

Shave down the boxes to grasp the actual shape.

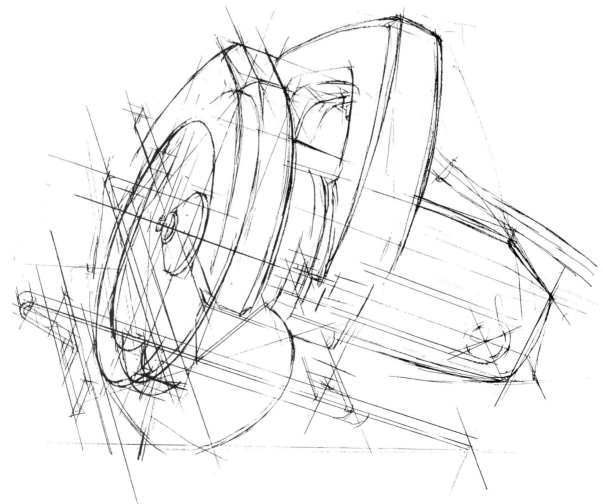

將數個箱型組合，以削去法塑出馬達的部份，再和鋸子一起組合。

Several box-shapes were joined together and cut down to create the motor section and the blade is joined to this through the central axis.

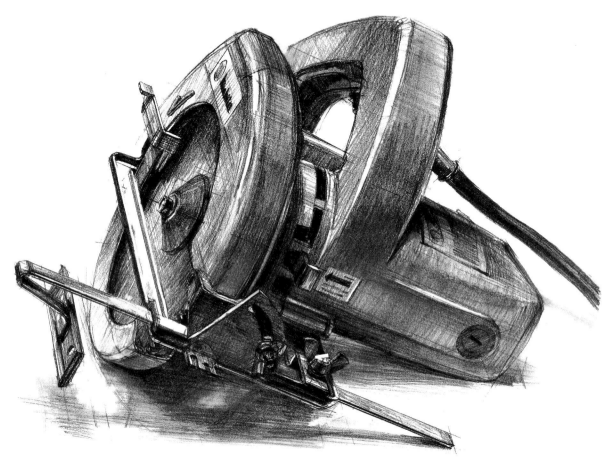

以沿構造線方向的筆觸加上陰影。

Add shading along the direction of the framework to create tones.

描繪輪廓的過程　　The Process of Grasping the Shape

先以水平垂直或包圍線確定整體的大小及大致的形狀。

The overall size and shape should be checked through the use of vertical and horizontal lines as well as the rough outline.

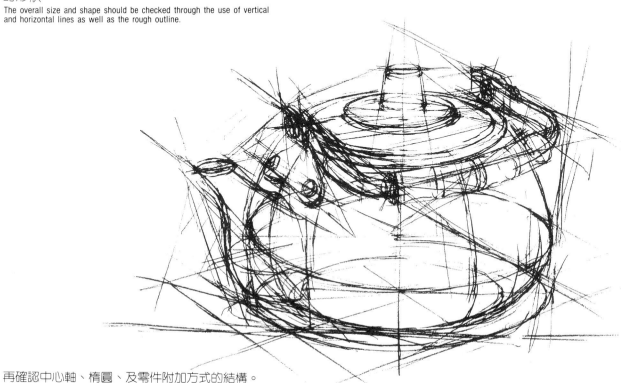

再確認中心軸、橢圓、及零件附加方式的結構。

Check the central axis, the ovals and the way in which the various parts are joined together.

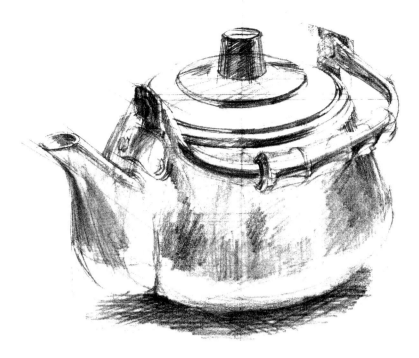

描出基本的色調。　　　　　Add tones to build up the basic shape.

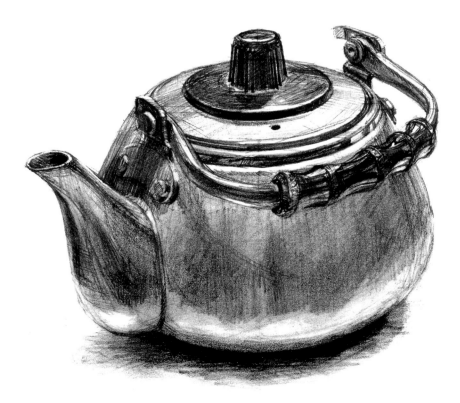

完成。　　　The finished drawing.

透視圖法

Perspective

這是利用愈遠的東西看起來愈小的原理的一種圖法。依深度表示之不同，可分爲一點透視、二點透視及三點透視等三個方法。在描繪建築物或箱型物時，利用透視圖法即可表現出有深度的空間。而把箱形物以外的東西置換成箱形物的話，也仍然可以表現出它的深度。

This technique is based on the fact that the further away an object lies, the smaller it appears. There are three methods of expressing depth and these are single point perspective, two-point perspective and three-point perspective. When drawing buildings or box-shaped objects the use of perspective will allow you to create an expression with a feeling of depth. Again, even when the subject is not in itself box-shaped, replacing it with a box-shaped outline will allow you to create an expression with depth.

一點透視

表現一個方向的深度時使用。消失點爲一個，畫面與所畫對象之正面平行。

Single Point Perspective

This technique expresses depth in a single direction. There is a single vanishing point and the surface of the subject is parallel to the surface of the picture.

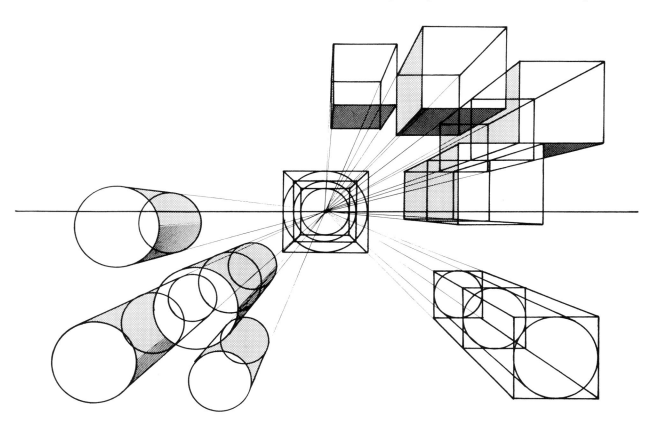

消失點。
Vanishing point

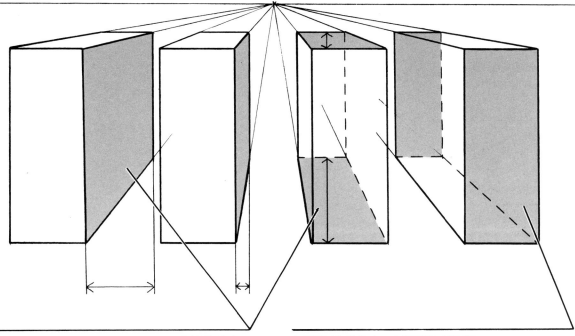

側面自消失點向外拓廣，底面離水平面愈遠則愈寬。

The further out from the vanishing point, the wider the side will become. The further the bottom surface moves from the horizontal, the wider it becomes.

正面愈深則愈小，但縱橫比例不變。

The further back the front section lies, the smaller it becomes, but the ratio between vertical and horizontal does not alter.

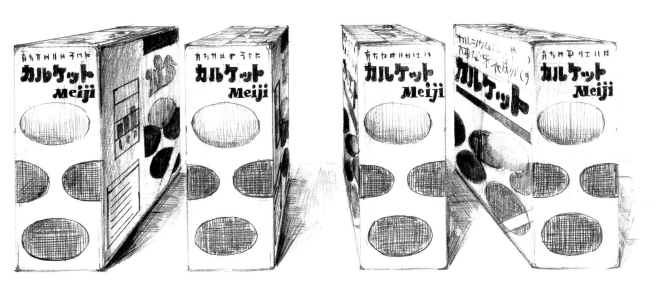

一點透視

箱型之室內的深度集中向一個消失點。兩側有柱或窗等成間距並列時，可用簡單的圖法分割出其位置。

Single Point Perspective

The sense of depth in a box-like interior should gather around a single vanishing point. Where columns or windows are set evenly down each side, a simple projection may be used to calculate their position.

等間距之8根柱子的作圖。

A picture with eight equally spaced columns.

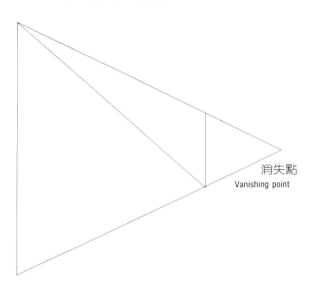

消失點
Vanishing point

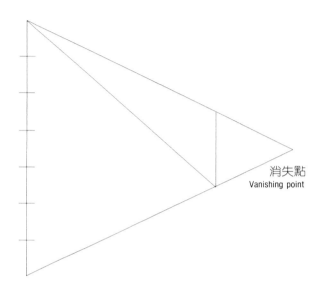

消失點
Vanishing point

1.決定第一根和最後一根柱子的位置，畫出對角線。

1. Decide where the first and last columns will be placed then draw the diagonal.

2.將第一根柱子七等分。

2. Divide the front column into seven equal parts.

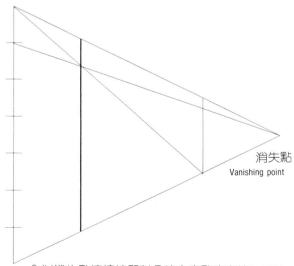

消失點
Vanishing point

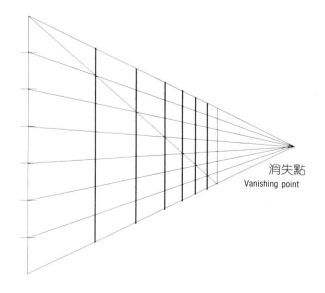

消失點
Vanishing point

3.以消失點連接線和對角線之交點決定第二根柱的位置。

3. The point where the line that joins the first section to the vanishing point crosses the diagonal is the position of the second column.

4.以同樣的方式定出後面柱子的距離。

4. The same method can be used to find the position of the remaining columns so as to create a feeling of depth.

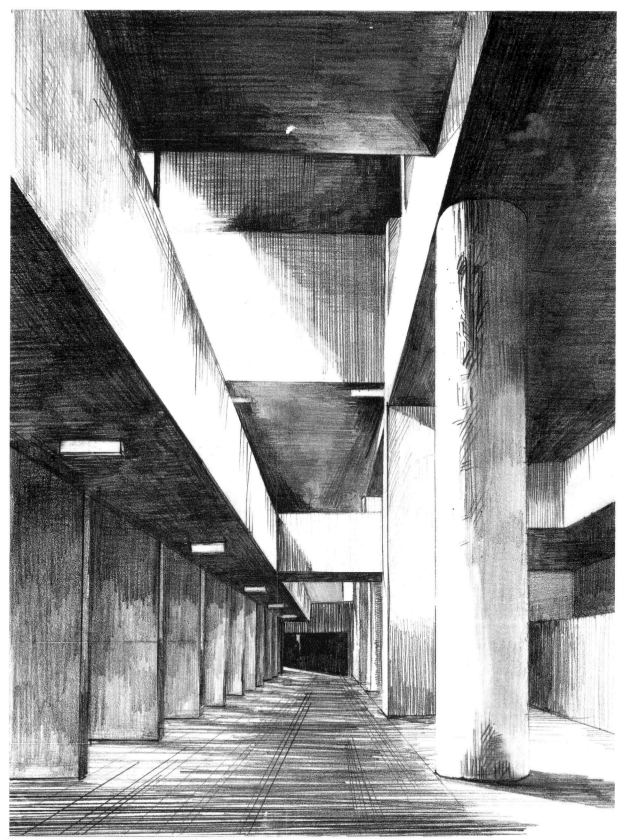

以一點透視畫出的室內：深度集中於一個消失點。 The drawing of an interior with Single Point Perspective : The sense of depth in this drawing should gather around a single vanishing point.

二點透視

將2個消失點設定在左右兩個方向，以表現有深度的面。

Two-point Perspective

This technique expresses depth through the use of two vanishing points, one to the left and one to the right.

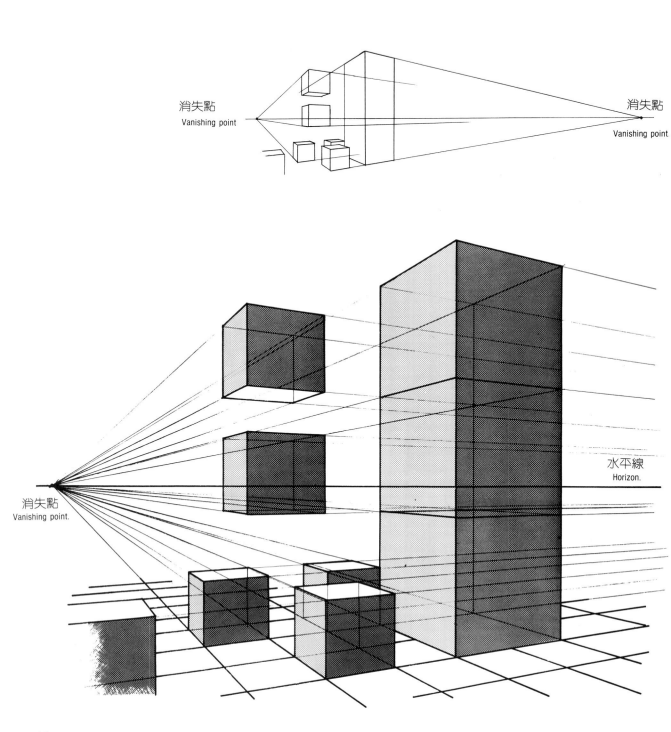

消失點
Vanishing point

消失點
Vanishing point

消失點
Vanishing point.

水平線
Horizon.

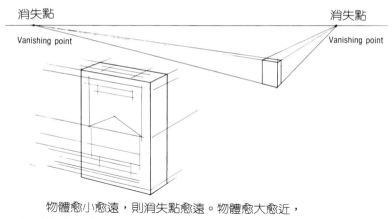

消失點
Vanishing point

消失點
Vanishing point

物體愈小愈遠，則消失點愈遠。物體愈大愈近，
則消失點愈近。

The closer the vanishing points lie, the shallower the appearance of depth.

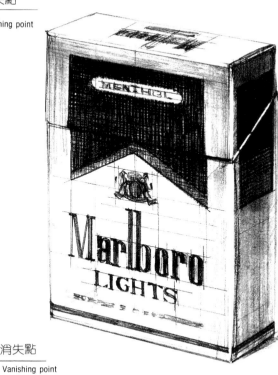

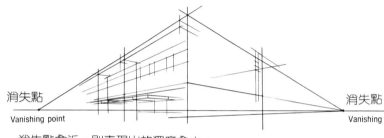

消失點
Vanishing point

消失點
Vanishing point

消失點愈近，則表現出的深度愈小。

The smaller and further away the subject, the more distant the vanishing points. The bigger and closer the subject, the closer the vanishing points.

三點透視

在左右兩方向的兩點透視之外，再加上上方或下方的深度表現。用於描繪向上或向下看的物體時。

Three-point Perspective

If a third vanishing point is added either above or below a subject using two-point perspective, it will create an impression of looking up or down on it.

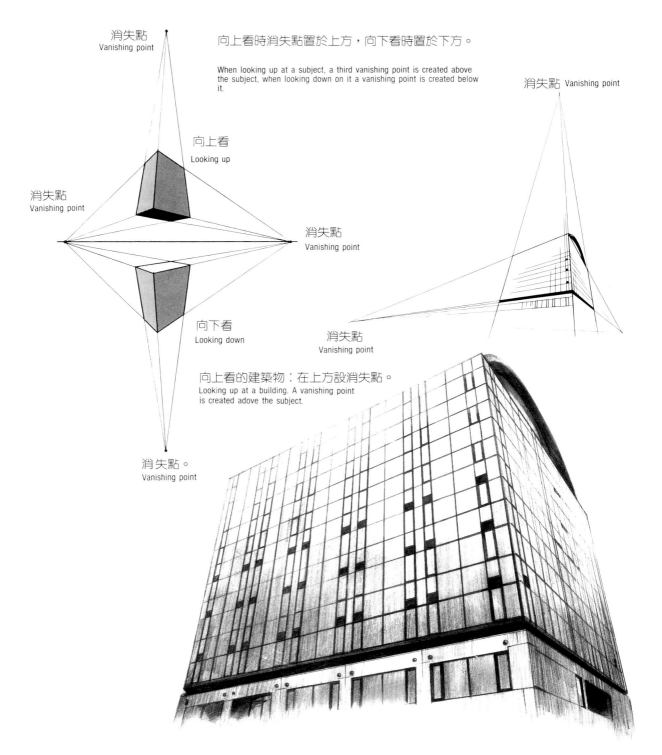

向上看時消失點置於上方，向下看時置於下方。

When looking up at a subject, a third vanishing point is created above the subject, when looking down on it a vanishing point is created below it.

消失點
Vanishing point

消失點
Vanishing point

向上看
Looking up

消失點
Vanishing point

消失點
Vanishing point

向下看
Looking down

消失點
Vanishing point

消失點 Vanishing point

向上看的建築物：在上方設消失點。
Looking up at a building. A vanishing point is created adove the subject.

消失點。
Vanishing point

向下看的椅子：在下方設消失點。

Looking down on a chair. A vanishing point is created below the subject.

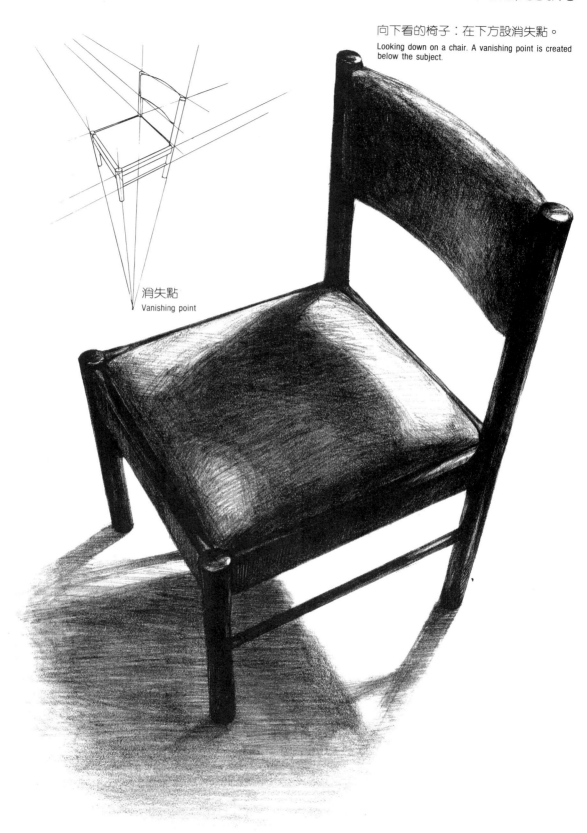

消失點
Vanishing point

透視圖法之應用
Applying the Rules of Perspective

即使像人體一樣複雜的形體，也可當成有深度的東西來處理。

A complicated shape like a human figure is able to grasp using perspectives.

距離1公尺所畫的人物。
近距離看到的人物的腳，有很大的深度變化。

A portrait drawn from 1 meter distance.
Note a larger variation of the size of the model's feet.

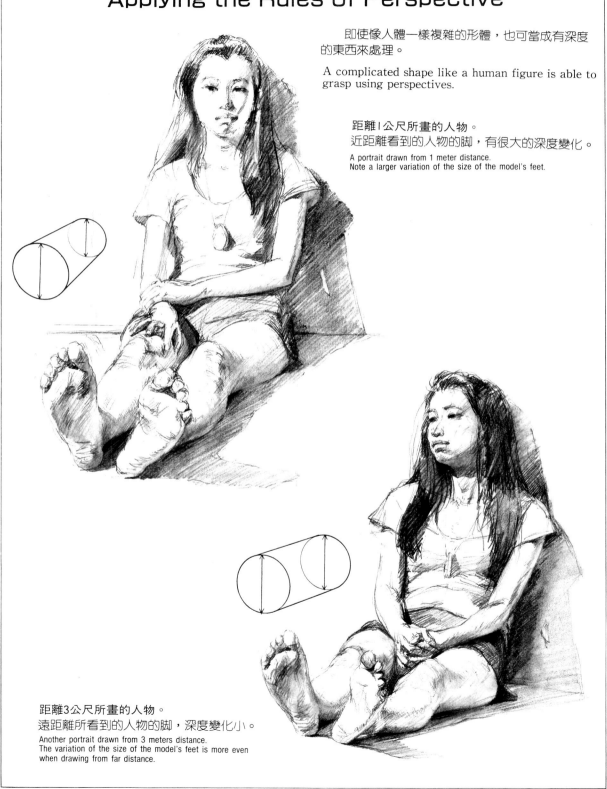

距離3公尺所畫的人物。
遠距離所看到的人物的腳，深度變化小。

Another portrait drawn from 3 meters distance.
The variation of the size of the model's feet is more even when drawing from far distance.

第 3 章
線條與明暗

Chapter 3
Lines and Shading

素描的要素
The Elements of a Sketch

線條　筆觸　明暗

　　鉛筆素描是由『線條』『筆觸』『明暗』三大要素所構成。通常會三者並用，但因表現之目的不同，也可以只用到其中之一。

Lines Shading Tones

A pencil sketch is comprises of three elements ; Lines, Shading and Tone. Usually all three are used in conjunction with each other, but depending on what you wish to express, a single element may be ample.

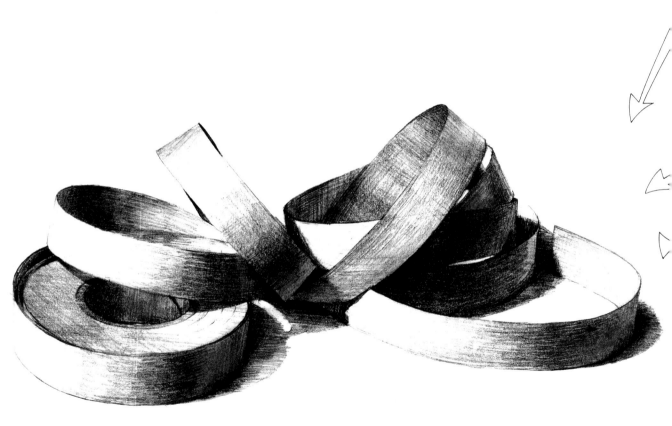

融會三個要素的表現
利用每一項優點以互補的綜合式的表現。

A Sketch Using All Three Elements.
The advantage of each element has been utilized to hide the shortcomings of the others and produce a comprehensive expression.

只有線的表現
在線條上以強弱表現遠近、連線、及分開的部分。

A Sketch Using Only Lines
By varying the pressure of the lines it is possible to show which areas are in the foreground and which are in the rear, where they touch and where they are do not.

只用筆觸的表現
筆觸帶有方向性,可以強調面的立體感。

A Sketch Using Only Shading
Giving the shading a direction in order to produce the shape and stress the feeling of depth.

只有明暗的表現
賦予明暗的變化,藉陰影之描繪表現空間。

A Sketch Using Only Tones
Add variety to the areas of light and shade. Show the shade and shadows to create feeling of space.

線條
Lines

線條可以畫出物體的形狀。試著變化鉛筆的強弱或粗細來畫出線條。

Lines express the shape of the subject. Try making variations through strength/weakness or the bold/fine lines.

強調重點線可以表現出立體感。

By stressing the lines of the main features it is possible to create a feeling of depth.

加上明暗之後的作品。

A sketch with tones added.

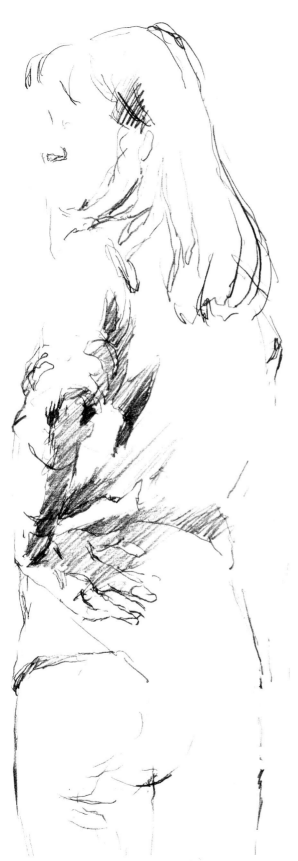

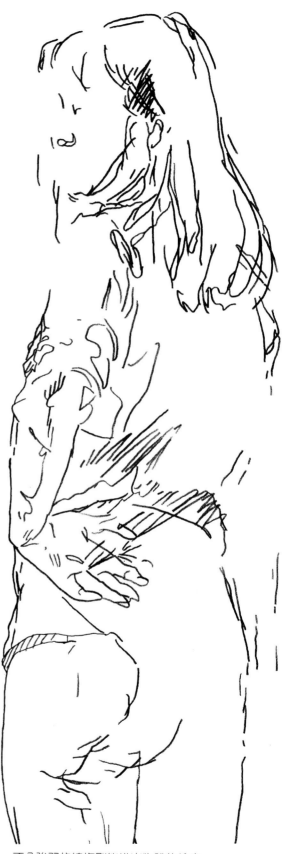

強弱的變化可使線條表現出立體感。

The weak and strong lines combine to create a feeling of depth.

不分強弱的線條則能描出物體的輪廓。

If all the line are drawn without any emphasis, it simply creates an outline.

筆觸
Shading

使用不同的筆觸，可以強調物體質感的變化。

Various types of shading should be used to stress the different textures within the subject.

豎直鉛筆所畫出的長筆觸。
Shading applied using long strokes with the tip of the lead.

橫壓鉛筆所畫出的長筆觸。
Shading applied using long strokes with the side of the lead.

豎直鉛筆所畫出的短筆觸。
Shading applied using short strokes with the tip of the lead.

橫壓鉛筆所畫出的短筆觸。
Shading applied using short strokes with the side of the lead.

橫壓鉛筆所作的柔和表現。
A soft gradation applied using the side of the lead.

將左圖弄朦朧的表現。
The shading on the left was blended with a tortillon.

依題材質感之不同而使用不同的筆。

Different types of shading used for each of the different textures in the subject.

綿：在白紙上以朦朧的筆觸表現柔和感。

Cotton : The white of the paper and blending was employed to create a feeling of softness.

金屬：以直線化的筆觸表現尖銳感。

Metal : Straight lines were used in the shading to produce a sharp feeling.

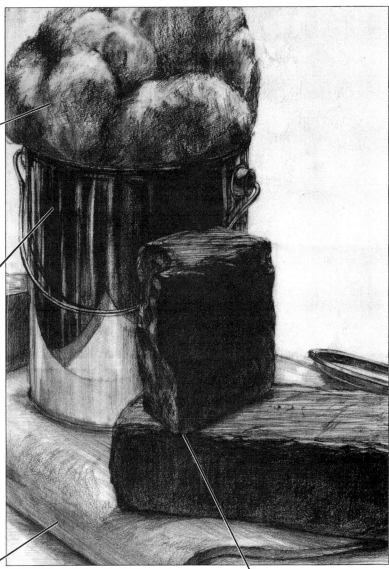

席：色調和棉一樣。再加上直線，表現出柔軟的質感。

Mat : The tone is the same as that of the cotton. Shading with straight lines was added to create the softness of the texture.

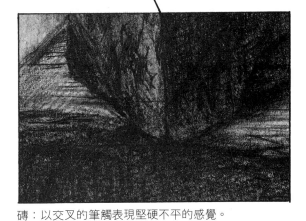

磚：以交叉的筆觸表現堅硬不平的感覺。

Brick : Shading using crossed lines produces a rough texture.

表現立體感的筆觸

　　物體具有平面、曲面、凹凸等各式各樣的形態。為了表現各個面的形態，就要用順著其面的方向或角度的筆觸來增加立體感。

Shading to Create Depth

An object contains numerous shapes, flats, curves and unevenness. If each of these shapes is grasped as a plane and the shading applied along the this plane or following the angle of a curve, a feeling of depth may be achieved.

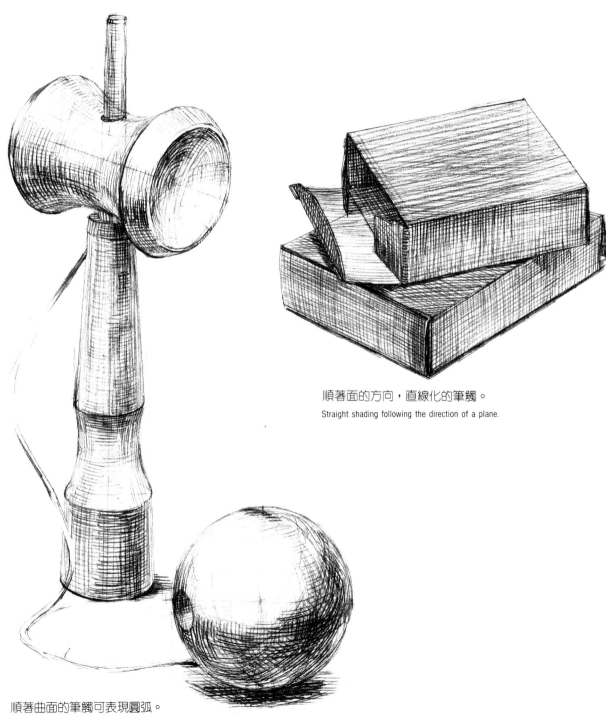

順著面的方向，直線化的筆觸。
Straight shading following the direction of a plane.

順著曲面的筆觸可表現圓弧。
Shading following a curve to express a feeling of roundness.

順著面的方向、小段式的筆觸。

Short-stroked shading following the direction of the plane.

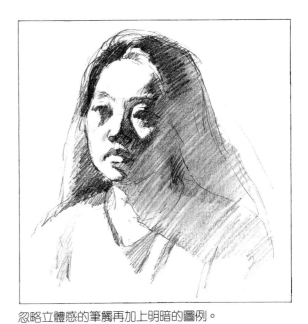

忽略立體感的筆觸再加上明暗的圖例。

An example of a sketch where the tones have been added ignoring the feeling of depth.

順著面的方向，以粗密的筆觸表現立體感。

Rough and fine shading following the direction of a plane to create a feeling of depth.

明暗
Tone

基本的色差有三種
Three Basic Tones

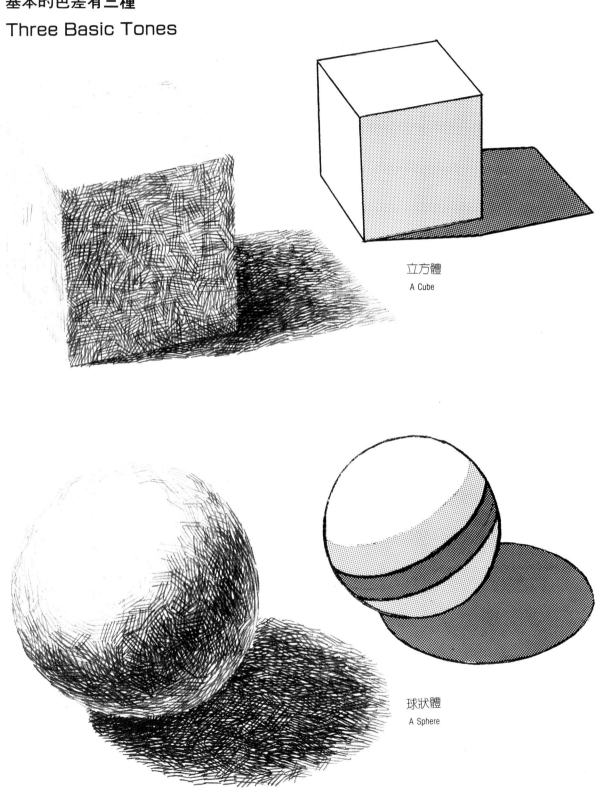

立方體
A Cube

球狀體
A Sphere

試著以明、中、暗三種明度來畫出基本的明暗。最亮的部份可以利用紙張的空白。想想看最暗的部份應在哪裏？或是應該如何表現地面反射上來的光。

Grasp the overall tone of the subject and express it three basic tones, light, mid and dark. The brightest areas in a picture make use of the white of the paper. Thought should be given as to where the darkest tones fall and where light is reflected from the ground.

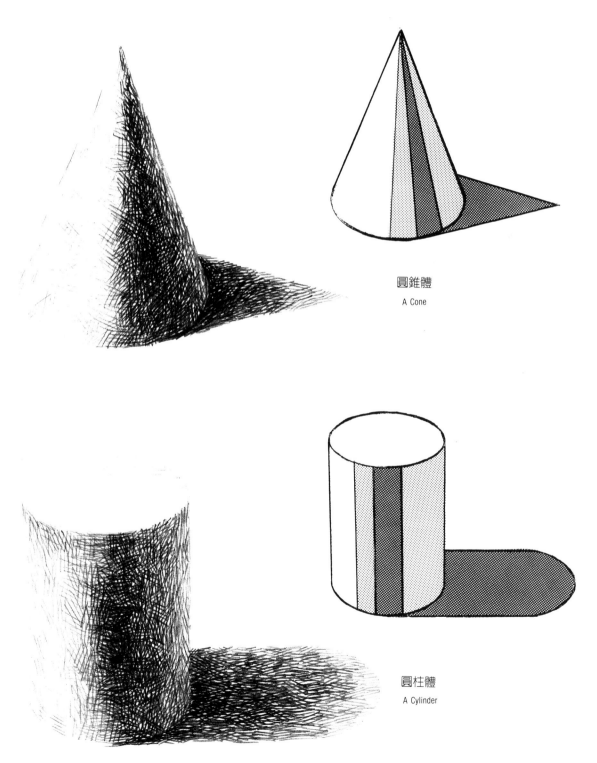

圓錐體
A Cone

圓柱體
A Cylinder

利用色差的特質 　　　　　　　Altering the Texture of Tones

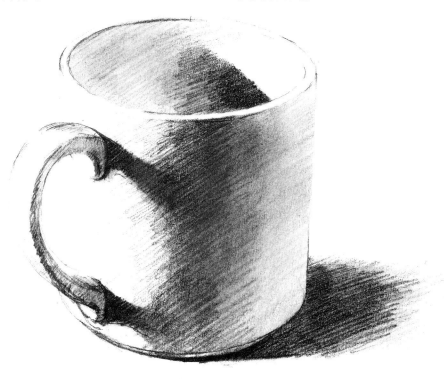

色調的特質有所不同
Differences in the Texture of the Tones.

明亮的部分：利用紙張留白的清爽感。　明暗界線的部分：比較濃的深色調。

Bright Areas : The white of the paper is left and the tone added lightly.

The Border Between Light and Dark : A dark tone is added sparingly.

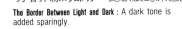

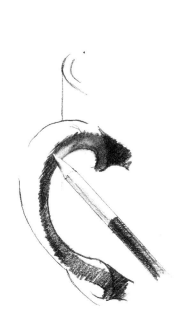

細的部分以擦筆弄朦朧。

Small areas are blended using a tortillon.

反射光的部分：塗滿紙張的平滑感。

Areas of Reflected Light : A smooth tone that flattens the texture of the paper is used.

影的部分：清晰而重的色調。

Shadow Areas : A clear, dark tone is used.

明暗應隨著光的方向而有不同。利用明亮、陰暗、反射光、陰影等不同的色調來畫才能表現真實的空間感。

The quality of a tone alters depending on how the light hits it. The feeling of reality can be heightened if the tones are drawn differently for the areas of light, shadow, reflections and shade.

利用色差的特質來畫。 Using Suitable Tones When Drawing

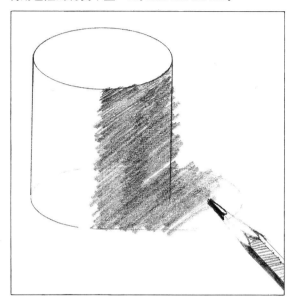

1.橫壓鉛筆、以重疊的筆觸爲陰暗的部份上色。

1. Add the dark tones of the shadow areas using the side of the lead.

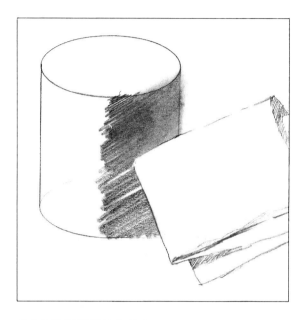

2.以面紙弄朦陰暗的部分，創造一種平滑感。

2. Rub the dark area with a paper tissue to achieve a smooth tone.

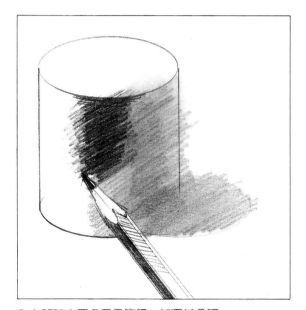

3.在明暗交界處重疊筆觸，加深其色調。

3. Build up the shading on the border between the light and dark to produce a rough tone.

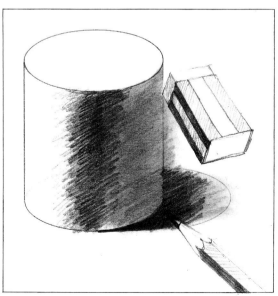

4.在陰影部分塗上深色，並用橡皮將邊緣弄出俐落的感覺。

4. Add a dark tone to the shadow areas. Use an eraser to produce a sharp line along the edge.

明暗的特質不變

　　雖然我們用不同的色差去表現不同顏色的明度，但其明暗色差的基本特質卻和描繪白色物體時是一樣的。

The Quality of the Tone Does not Change

Although different tones are used to express different colors, the basic use of the tones is the same as when expressing a white object.

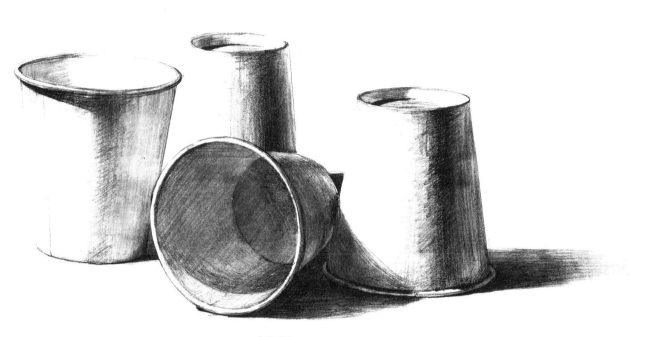

白紙杯。　　A white paper cup

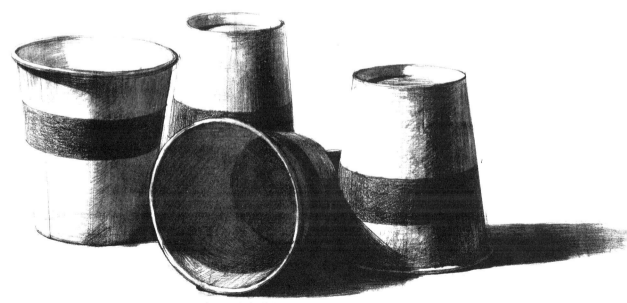

有不同顏色的杯子。　　Different colored paper cups

細部的色差

　　描繪細部時，要分別描出明亮部份、陰暗、反射光、陰影等色差的特質。

Tones in detailed areas
When drawing in detail there should be a tonal difference between the areas of light, shadow, reflection and shade.

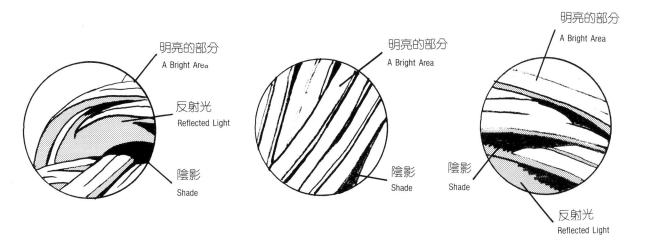

明亮的部分
A Bright Area

反射光
Reflected Light

陰影
Shade

明亮的部分
A Bright Area

陰影
Shade

明亮的部分
A Bright Area

陰影
Shade

反射光
Reflected Light

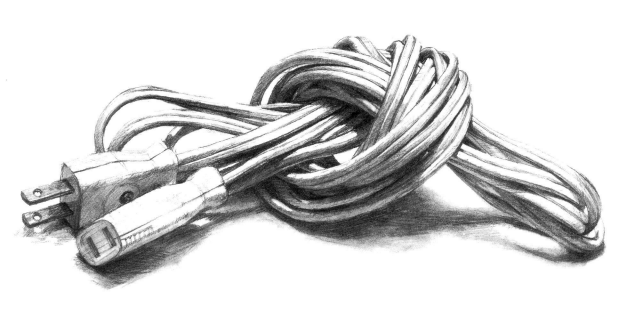

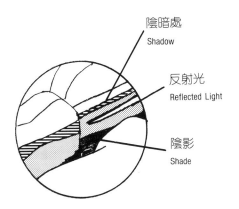

陰暗處
Shadow

反射光
Reflected Light

陰影
Shade

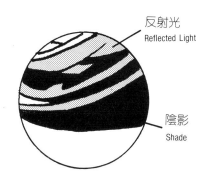

反射光
Reflected Light

陰影
Shade

磨擦以創造色差
Tone Produced by Rubbing

　　將鉛筆的筆跡以擦筆或面紙、手指摩擦使其
畫面朦朧，可以創造出柔和的色調。

Pencil shading can be rubbed with a tortillon, paper
tissue or even the finger to blend the strokes and
produce a smooth, soft tone.

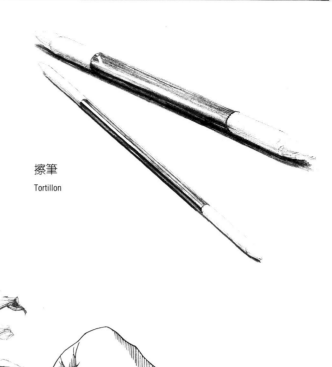

擦筆
Tortillon

將葉子的背面弄模糊，以和正面
之清晰區別。

The back of the leaves are blended to create a
clear contrast with the light tone of the front.

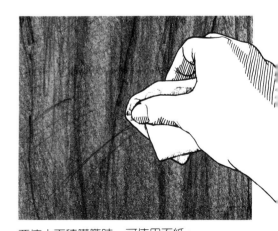

要使大面積朦朧時，可使用面紙。
Paper tissues are useful when blending a large area.

將鐵絲下面的反射光弄朦,可與上部的亮光區別。

Alter the reflecting light under the wire from the top highlight by rubbing and blending.

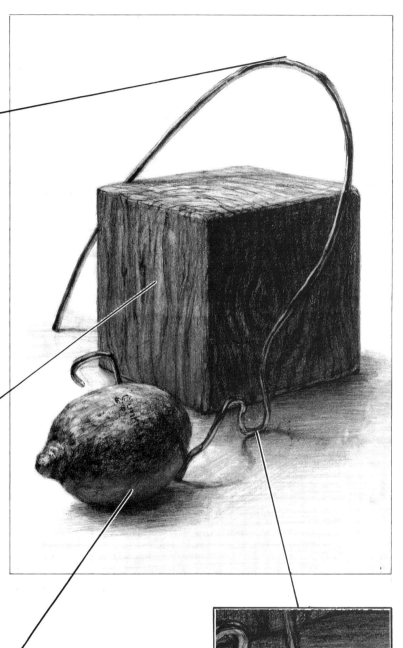

將立方體的一面弄朦,將易於與其他面區分。

If one of the surface of the cubes has a tone produced by rubbing, the other surface look more distinguished.

檸檬下部的反射光以朦朧的色調表示。

The reflecting light under the lemon is expressed by adding tones.

以朦朧的色調表現鐵絲的灰色。

Use a rubbed and blended tone for a grayish touch of the wire.

以可揉捏橡皮來創造色差

Kneadable Eraser

畫鉛筆畫的時候，可揉捏橡皮不是用來當修正的橡皮擦，而是用來當創造明暗色調的工具。

When drawing with a pencil, a kneadable eraser should not be thought of as a tool for erasing mistakes but rather one for creating tones.

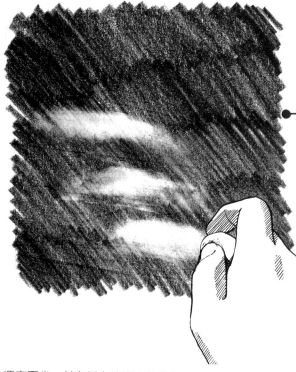

把它弄尖，並在紙上擦出白色的部分。

Make a point and rub it against the paper to lift out an area of white.

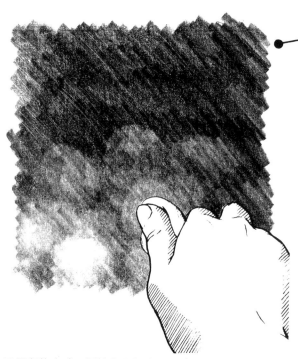

用壓印的方式，壓出部分的色差。

Press the eraser onto the paper to reduce the tone in areas.

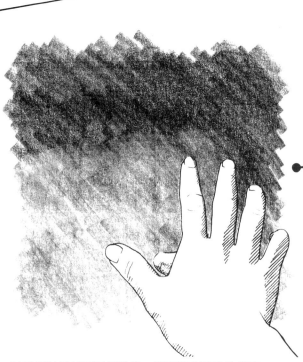

滾動圓柱狀的可揉捏橡皮，可創造全面性的色調。

Make the eraser into a cylindrical shape then roll it over the paper to suppress the overall tone.

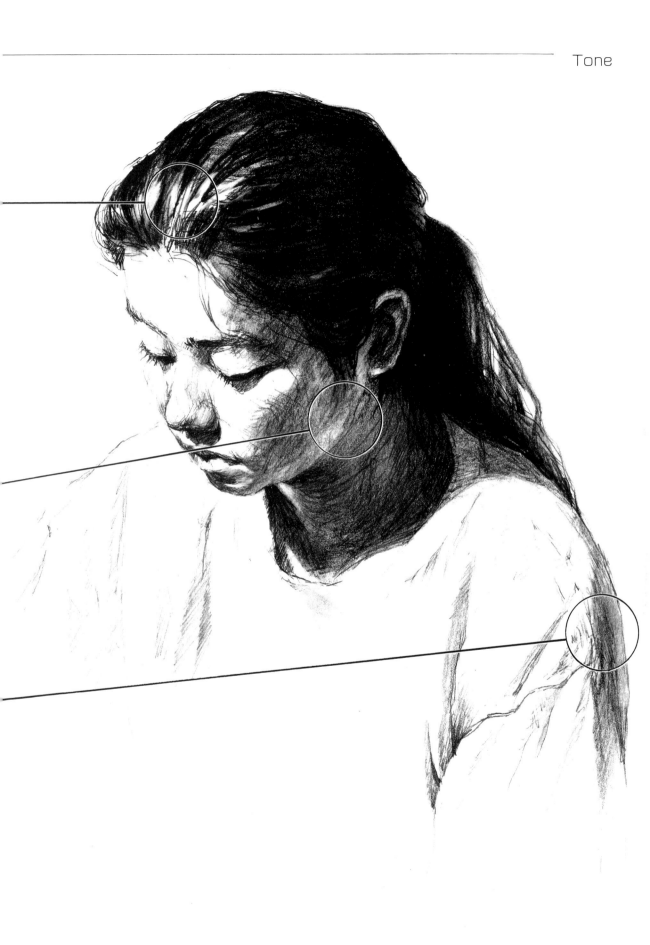

增加明暗的幅度

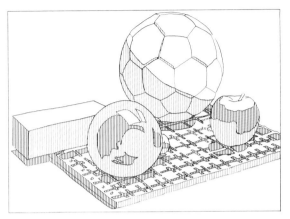

略去顏色，以基本的三種色調表現。

Ignoring the colors of the original, express the subject using the three basic tones.

Widen the Range of Tones

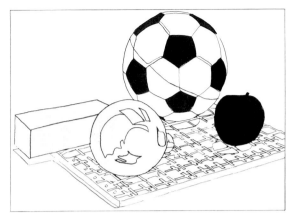

以三種色調去表示物體的固有色。

Using the three basic tones to express only the colors of the subject.

明亮的色調　Light tones

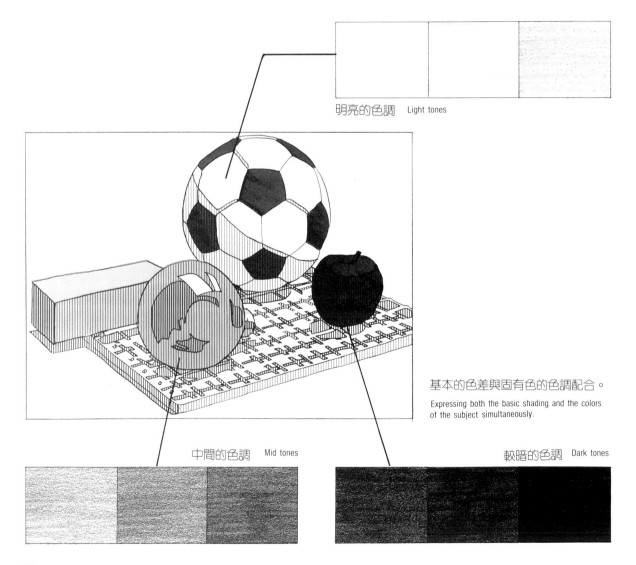

基本的色差與固有色的色調配合。

Expressing both the basic shading and the colors of the subject simultaneously.

中間的色調　Mid tones

較暗的色調　Dark tones

鉛筆素描因爲只有黑白兩種色調，所以必須視對象增加色差。試著在明中暗之外拓廣色差以鉛筆畫出豐富的色感。將明亮的色調分爲3層，中間色調分爲3層，暗色也分爲3層，便可產生9種色調。

When drawing with pencils, one has to represent the colors of the subject in monochrome so sometimes it is necessary to increase number of tones used. Try widening the range of the three basic tones and take advantage of the rich tonal variety that the pencil provides. If the light tonal range is divided into three, the mid tonal range divided into three and the dark tonal range divided into three it will provide a range of nine tones.

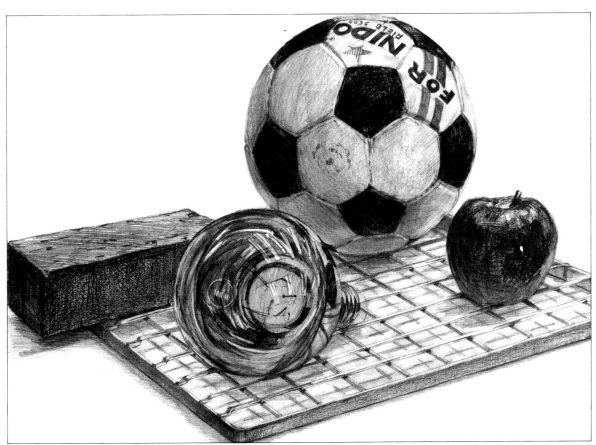

各種狀態下產生的陰影、亮光，再加上固有色的色差，就可以拓寬鉛筆畫的色差幅度了。

Express the shadows and highlights then add the tones to represent the colors, expanding the depth of the tones that can be created with a pencil.

材質感
Texture

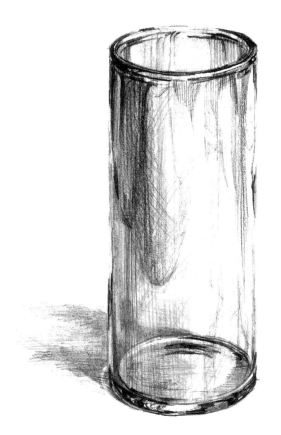 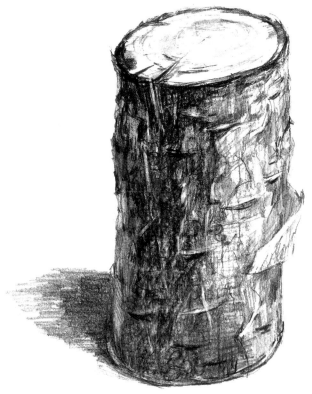

玻璃：以白色爲底時，中間至明亮的色調佔了大半。把清晰的亮光和反射加在中間色上。

Glass : When using a white background, use mostly mid- to light tones. Add clear highlights and reflections of the surroundings in the mid-tones.

木頭：以橫壓鉛筆畫出的暗部的柔和筆觸和較亮的灰色調之對比來表現。

Wood : Use the side of lead when shading and create a contrast between the soft, dark shading in the shadows and the grey of light areas.

表現在不同物體上的亮光、明暗、反射光之不同，和創造明暗的鉛筆之筆觸，可以決定所畫出的材質感。

A Feeling of texture may be created by expressing the unique highlights, shadows and reflections that occur in different items and by tonal differences created through shading.

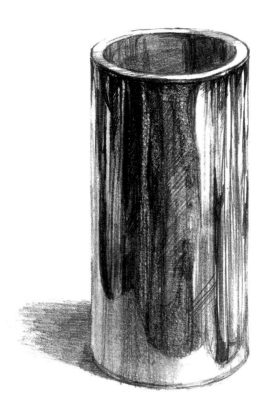

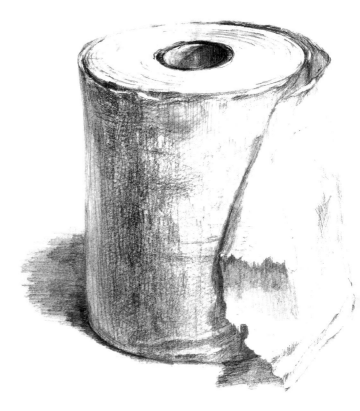

金屬：以明中暗三種色調極端的對比，及直線感的筆觸，來表現俐落的堅硬度。

Metal : Use clear contrast between the three tones, light, mid- and dark. Use straight lines when applying the shading in order to express the hard surface.

紙：明亮的部分只要輕加色澤。較暗的部分以中間色表示。利用陰影來表現紙張的白色。

Paper : Use very light shading in the bright areas. The dark areas should use a lightly applied mid-tone and should contrast strongly with the dark shadow areas in order to express the whiteness of the paper.

人物的質感與色調
The Texture and Tones of Human Figures

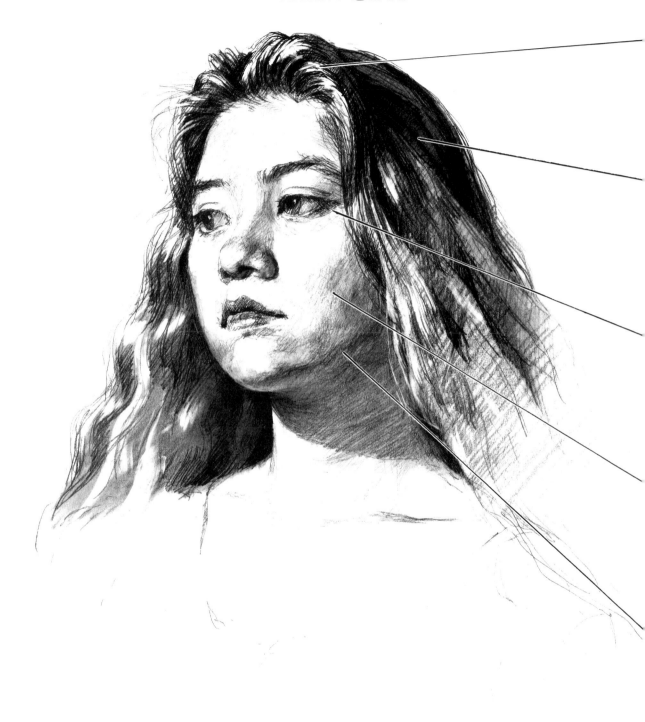

利用不同色差來畫頭髮、肌膚、眼睛等不同部分的人物素描。

A sketch of a figure in which the tone has been altered to express the texture of the hair, skin, eyes, etc.

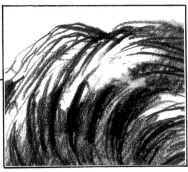

頭髮的亮光部分：以橡擦擦出紙的白色，並在邊緣加上深色。

The highlights in the hair： The highlights are lifted out using an eraser and the surrounding area is added in a dark tone to draw it together.

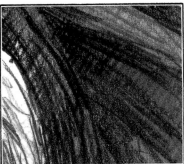

頭髮的陰暗部分：以面紙擦出朦朧的重色為底，再畫上黑色的線條。

The dark areas of the hair： The base is created by rubbing a dark tone with a paper tissue to create a flat tone then black lines added to express the strands of hair.

眼睛：黑眼珠和睫毛以深色，亮光以紙的白底，眼白部分則以淺色表現。

Eyes： The pupils and the eyelashes are added in a dark tone. The white of the paper is used for the highlights and the whites of the eyes are added using a light tone.

肌膚的亮處：像留白一樣的清爽色調。

The light areas of the skin： A light tone is added leaving the white of the paper.

肌膚的暗處：以面紙擦出由中間色調到深色調的柔和感。

The dark areas of the skin： A paper tissue is used to rub the surface and create a smooth gradation from mid-tone to dark.

用明暗的對比表現遠近感

Expressing Depth Through Tonal Contrast

愈近則愈重，愈遠則愈輕。或是愈近畫得愈仔細，愈遠則愈粗略朦朧，都可以表現出遠近的感覺。

Use strong tones for the foreground, becoming lighter as they move into the distance. Again, the foreground may be drawn clearly while the background becomes blurred and indistinct to create a feeling of depth.

比較近景之樹木與遠景之樹木。
Contrast the trees in the foreground with those in the rear.

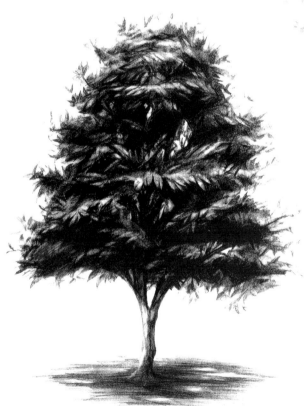

遠景：色調的明暗對比變弱、變淡、變輕。

Background : The tonal contrast has been removed and light weak tones used.

近景：密密地重疊仔細的描繪。
Foreground : The buildup of the foliage is expressed clearly.

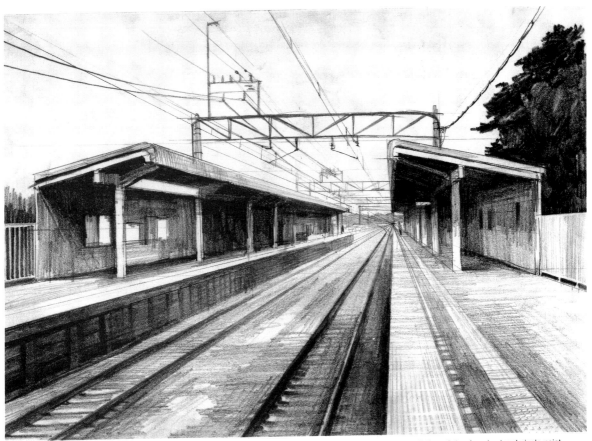

利用一點透視與明暗對比的素描。

A sketch that expresses depth through tonal contrast and single-point perspective.

細畫近景。

The foreground is drawn in detail.

遠景以約略手法表現。

The details in the background are simplified.

愈近對細部畫得愈清楚，愈遠則愈粗略，可以強調遠近感。

The foreground may be drawn clearly while the background becomes blurred and indistinct to create feeling of depth.

第 4 章
表現與技巧

Chapter 4
Expression and Technique

凹面與凸面

Protruding and Recessed Surfaces

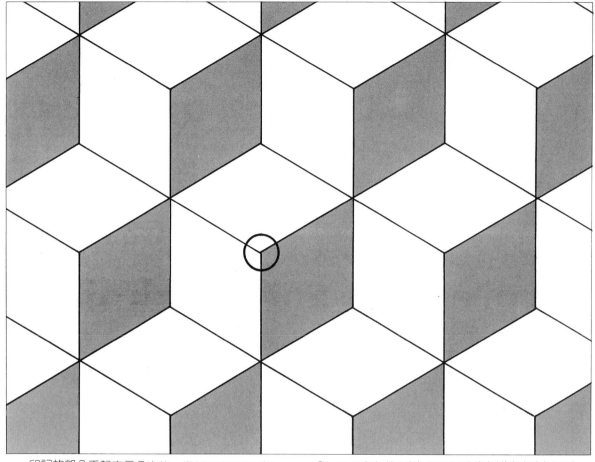

印記的部分看起來是凸出的，但若將書反拿，則看起來像凹陷的樣子。

The area marked with a circle appears protrude but if the book is turned upside down it will then appear recessed.

中間四方形看起來是凸出的。

The central square appears to protrude.

中間四方形看起來像凹陷的。

The central square appears to be recessed.

人的視覺會受以亮面為向上的面，以暗面為向下面的心理影響。試著將素描時的光源設定在上方或斜上方、捕捉光與影的關係。

People have a psychological tendency to automatically assume a light surface faces upwards and a dark surface faces down. When making a sketch, the light source should be situated above or diagonally above the subject and attention paid to the relationship of light and dark.

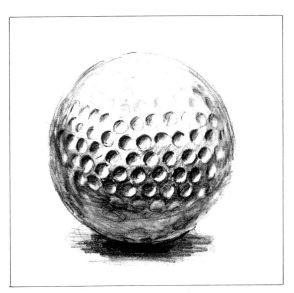

高爾夫球有凹面與凸面。

A golf ball has both protruding and recessed surfaces.

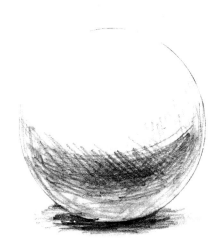

沒有凹凸的球體。

A smooth sphere

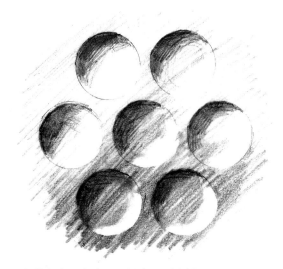

光源來自斜上方，所以表面看來像凹面。

The light source has been situated diagonally above the subject so the dimples appear recessed.

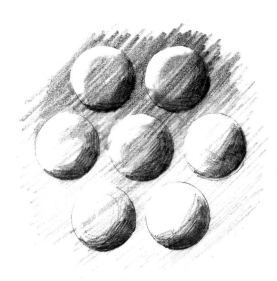

反之，則像凸面。

If the light source is reversed, the dimples appear to protrude.

白襯衫與黑襯衫
White Shirts and Black Shirts

白襯衫

　　強調襯衫皺摺部分的陰影，整體較膚色為亮。利用深色調來畫肌膚以表現襯衫的暗白色。

White Shirt
Stress the contrast of the shadow areas of the creases but make them appear lighter overall than the skin tones. By using a dark tone for the shadow areas of the skin it creates a feeling of darkened whiteness.

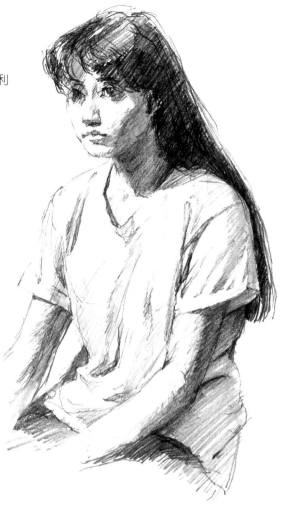

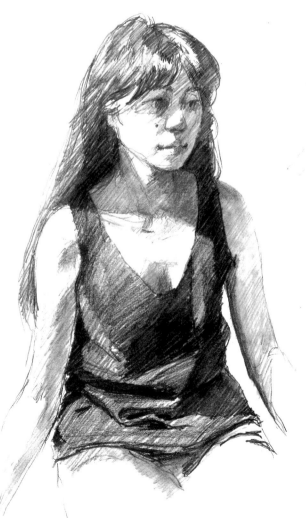

黑襯衫

　　肌膚的陰影和黑襯衫的明亮部分為同一明度，但以色調的質來表現其不同處。肌膚部分用擦筆將鉛筆的筆跡弄模糊，襯衫部分則用鉛筆來表現色調。頭髮部分則在某部份強調比襯衫更有對比的明暗。

Black Shirt
The dark shadow areas of the skin are the same tonal brightness as the light areas of the shirt but a different texture should be used to express the difference. The shading of the skin has been blended with a tortillon while the strokes of the pencil remain in the shading of the shirt. In places, the contrast of light and shade in the hair is made stronger than that of shirt.

互相突顯肌膚或頭髮的色調與襯衫明暗的色
調為重點。

The secret when drawing a portrait like this is to
make the tone of the hair and skin to work with
the color of the clothes and make each other stand
out.

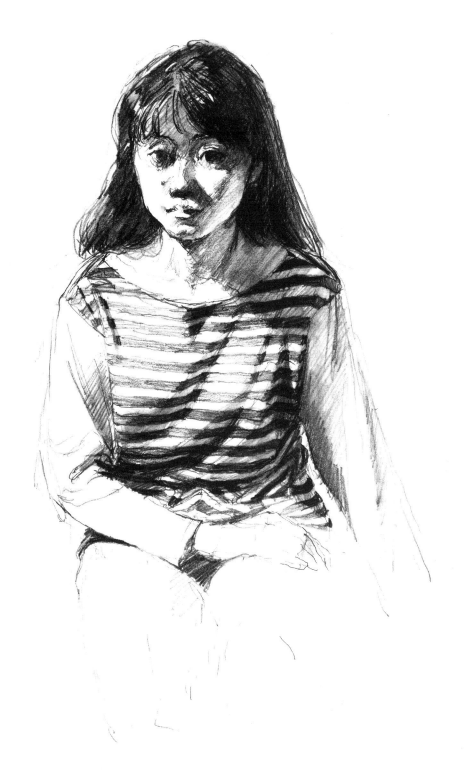

花色襯衫

　順著皺摺的形來描畫花色，以白襯衫和黑襯衫的
色差要素加上陰影。

Patterned Shirt
The pattern is portrayed following the creases in the shirt. Add the
shading and shadows in the same way as for the black and white shirts.

扭曲形狀
Distorting the Shape

以「變形自畫像」為題的素描
。為發掘與平常不同之形狀,利用
一面扭曲的不銹鋼板來當鏡子,忠
實地畫下其中的容顏。

A simple sketch whose aim was to create a
distorted self-portrait. In order to find a new
shape, a sheet of dented stainless steel was used
as a mirror and the image in it was drawn
accurately.

以線條、筆觸或明暗來描畫各種形與色的基本技巧是本書的目的之一，而另一個目的，則是告訴讀者如何以創作性的角度去表現自我的形象或靈感。

One of the aims of this book is to teach the basic skills required to depict various shapes and colors through black and white shading and tones. The other is to show how to create simple sketches that express your own image or ideas in a creative way.

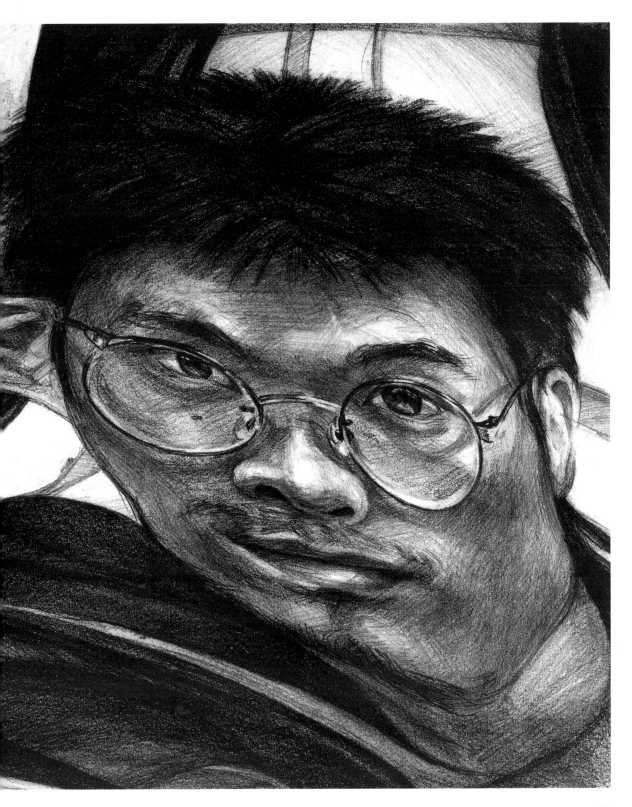

模型與實物

A Model and the Real Thing

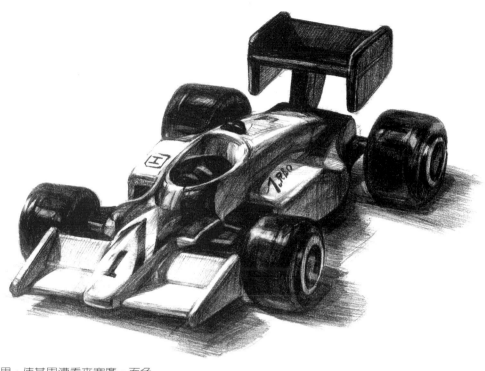

模型：利用俯視效果，使其周遭看來寬廣，而色
差的幅度縮小也會使其感覺比實物小。

A Model : The feeling of scale looks smaller by taking the viewpoint from top
to create larger surroundings, and increasing number of tones used.

實物：採較低的視點，利用輪胎和車體微妙的色
差變化使其感覺比較大。

A Real Car : The feeling of scale looks bigger with the lower view point, as
well as the minute change of tones in tires and a body.

比例感的差異

　　大小的不同可以表現比例的差異，利用透視圖法的水平線和消失點的位置，即視點的改變也頗具效果。

Difference in Scale

The feeling of scale should change according to the size of the subject. When using perspective, the vanishing point and the horizon should altered, in other words, it is effective if the viewpoint is changed.

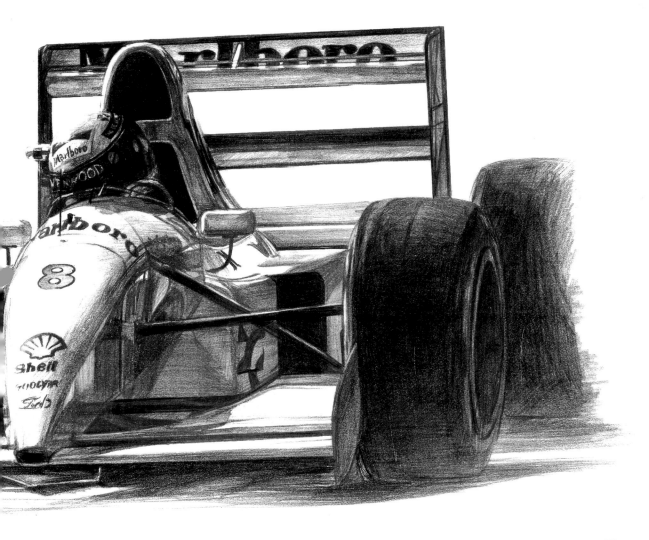

晴天與陰天
Clear Skies and Cloudy Skies

晴天：明暗對比較強。

Clear Skies : Strong overall contrast.

　　表現晴天時，要明顯表現出白紙明亮的部分和陰影的差別。

On a clear day the white of the paper is used for the highlights and the contrast with the shadows is very marked.

明暗對比之不同

屋外建築物的外表會受天氣影響。在晴天的陽光下,亮光和陰影區分明顯,顯現強烈的明暗對比。試著探索色差的利用,來畫出天氣的感覺。

The Difference in Contrast of Light and Shade

The appearance of the exterior of buildings is altered by the weather. On a sunny day, highlights and shadows are clearly defined and there is a strong overall contrast. The tones used in the picture may be changed to create an expression that reflects the feeling of the weather.

陰天:明暗對比較弱。

Cloudy Skies : Weak overall contrast.

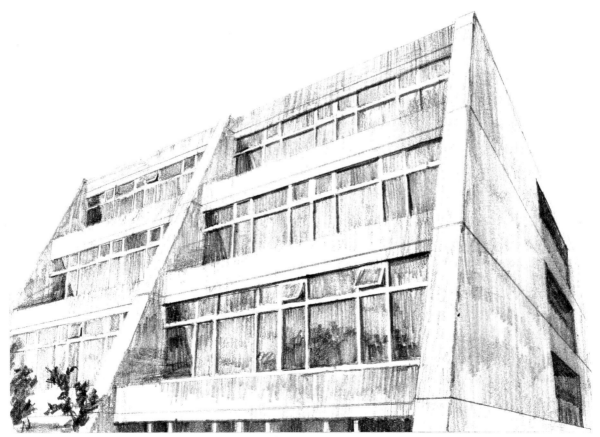

陰天的時候,呈現不明確的灰色部分較多,明暗對比不強。

On a cloudy day a muddy grey tone is widespread and the contrast is weak.

簡單化與精細化
Simplification and Detail

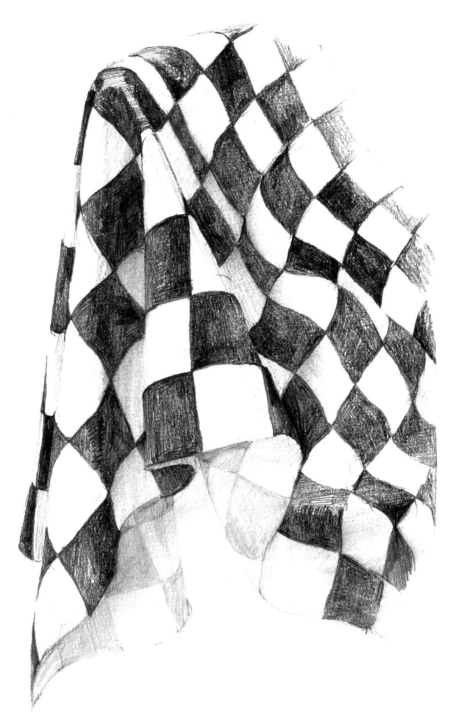

細畫布的花色：重點放在沿著皺紋呈現的花色形狀。明暗的色差大致省略，只用了一點點。

Drawing the Pattern on Material : A sketch in which the interest focuses on how the pattern follows the folds of the material. Very few tones are used in this sketch, the rest being simplified.

在學習素描的時候，抓住想表現的內容也是很重要的。試著強調一個要素，把不必要的要素省略。

When starting to sketch, one should learn to focus on the important areas of the subject. If one element of the subject is stressed while the unnecessary elements are abbreviated, it will provide the picture with a theme.

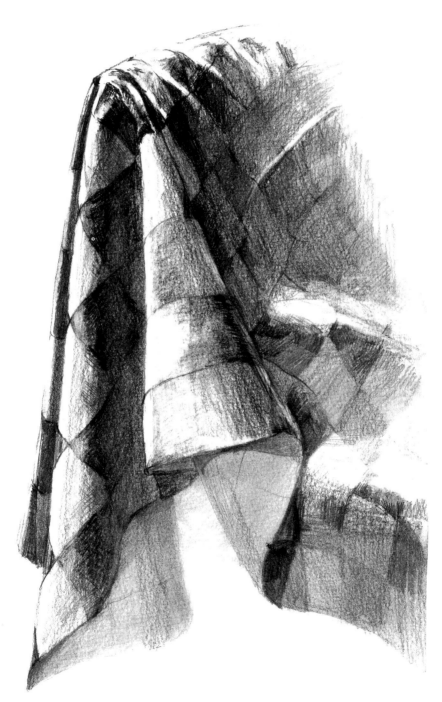

細畫布的明暗：重點放在表現布的起伏，省略花色的表現，而著重明暗的色差。

Drawing the Shading of the Material : The focus of this sketch lies in the shape and volume of the subject. The pattern has been simplified and stress laid on the tonal variety of light and shade.

畫有趣的對象

只細畫吸引人的主要部分，省略其他部分，只保留相關的重點。

Draw Areas of Interest in Detail

Draw the areas that interest you in detail and simplify the rest, just leaving enough to show their relationship.

只細畫你感興趣的部分。

Draw the areas that interest you in detail.

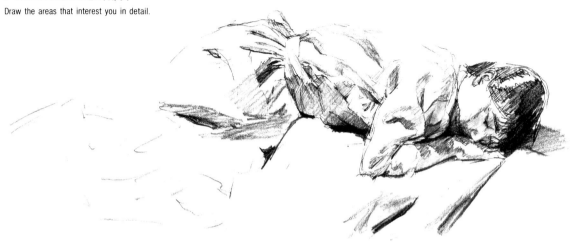

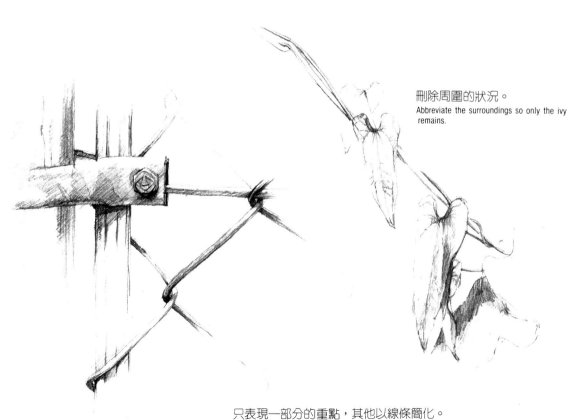

刪除周圍的狀況。

Abbreviate the surroundings so only the ivy remains.

只表現一部分的重點，其他以線條簡化。

Show details in places of how the wire is linked and simplify the rest.

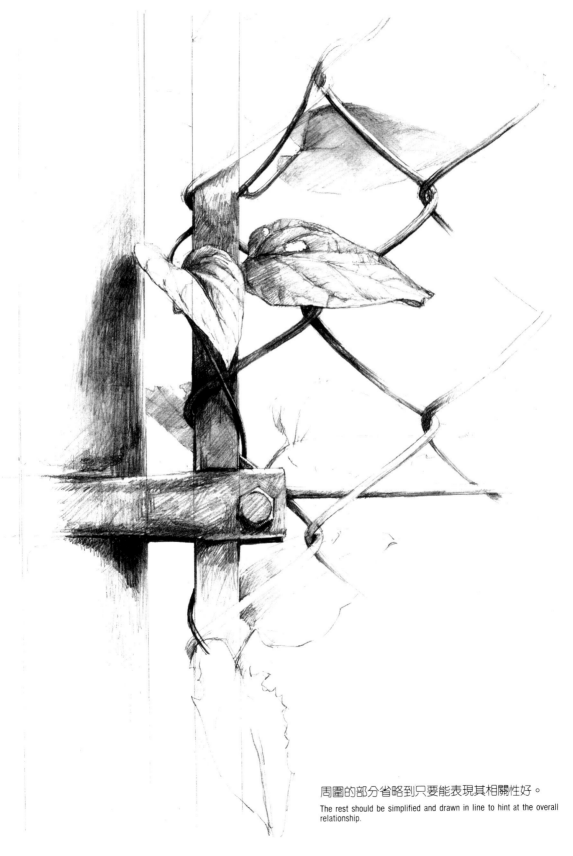

周圍的部分省略到只要能表現其相關性好。

The rest should be simplified and drawn in line to hint at the overall relationship.

93

光的省略

不只是細部的色差，將畫面以大致的明暗區分，省略光亮的部分或陰暗的部分。明暗對比愈強，戲劇效果愈烈。

Simplify the Light and Shade

Divide the picture into areas of light and shade then simplify the details of one of these. The more powerful the contrast between light and shade, the more dramatic it will appear.

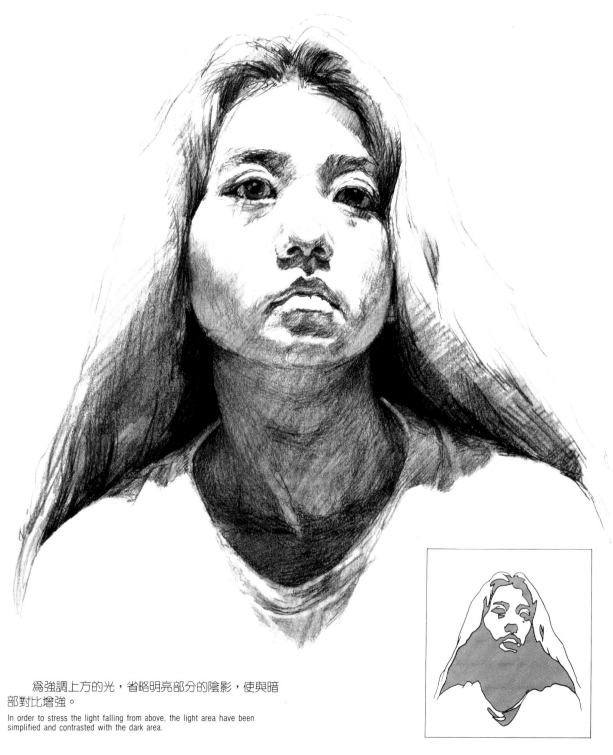

為強調上方的光，省略明亮部分的陰影，使與暗部對比增強。

In order to stress the light falling from above, the light area have been simplified and contrasted with the dark area.

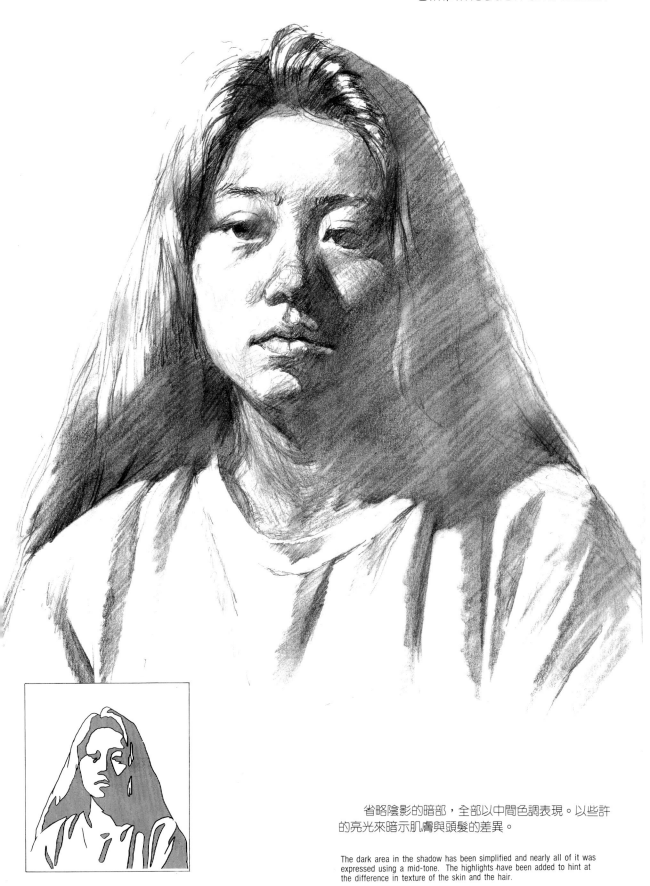

省略陰影的暗部，全部以中間色調表現。以些許的亮光來暗示肌膚與頭髮的差異。

The dark area in the shadow has been simplified and nearly all of it was expressed using a mid-tone. The highlights have been added to hint at the difference in texture of the skin and the hair.

粗略的表現與精細的表現

把對象的形與色用線條或筆觸作粗略的描繪。或是盯住對象,連質感都細細描畫。鉛筆的表現方式是可依當時之情況自由變化的。

Rough and Detailed Expressions

The shape and tone of the subject can be expressed roughly using lines and shading or it can be worked on in fine detail. Pencil drawing is a medium that allows you to alter the form of expression freely as the situation calls for.

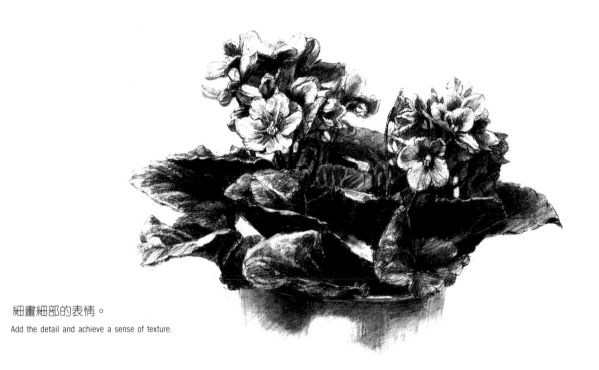

細畫細部的表情。

Add the detail and achieve a sense of texture.

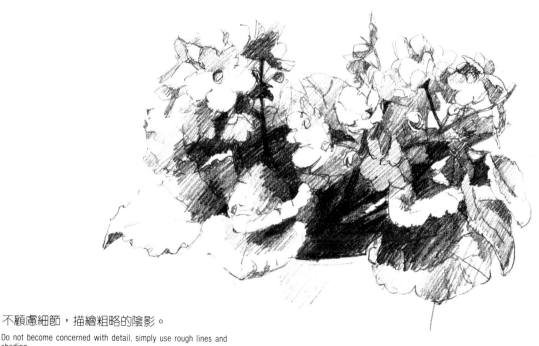

不顧慮細節,描繪粗略的陰影。

Do not become concerned with detail, simply use rough lines and shading.

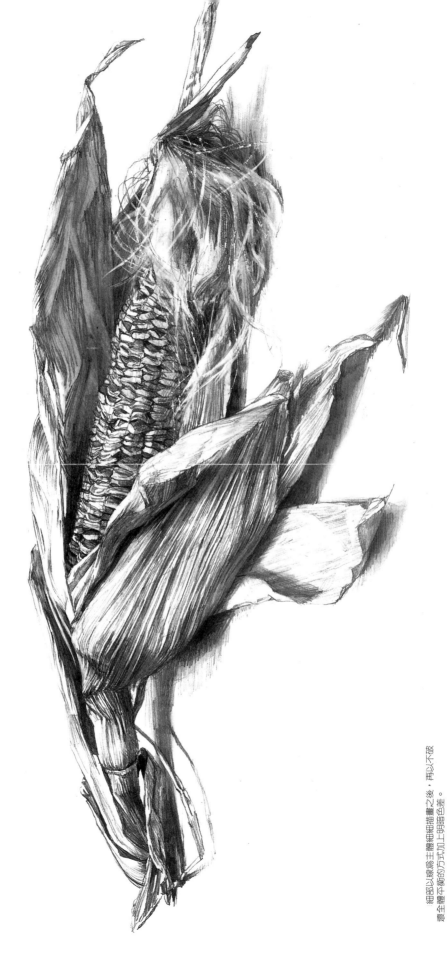

細部以線為主體細細描畫之後，再以不破
壞全體平衡的方式加上明暗色差。

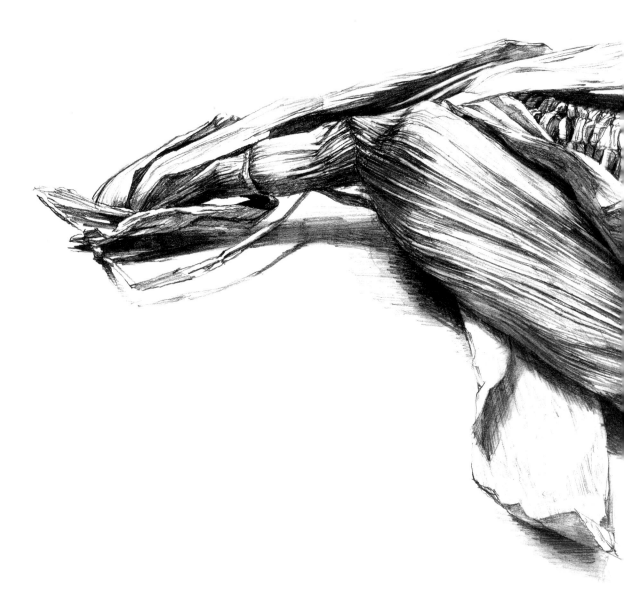

　　細部以線爲主體細細描畫之後，再以不破
壞全體平衡的方式加上明暗色差。

Draw clearly with lines and make additional tones but not to break the
entire balance.

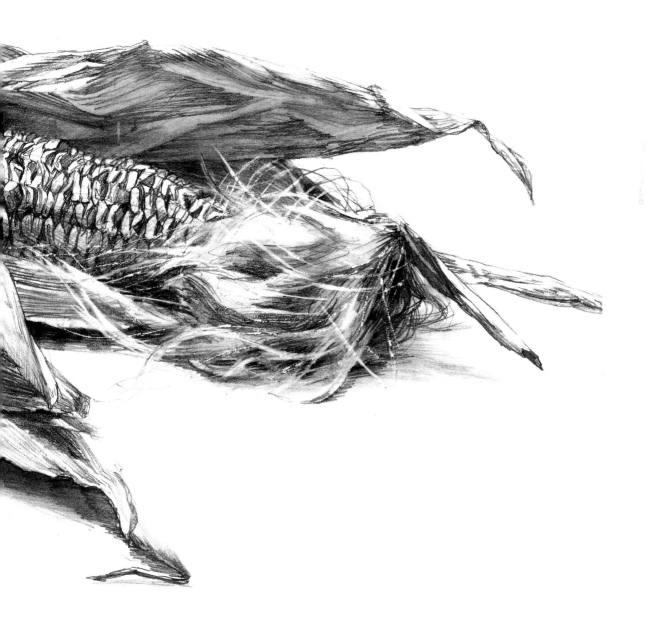

第五章
特殊的表現

Chapter 5
Special Expressions

用可揉捏橡皮素描
Drawing With a Kneadable Eraser

把鉛筆的粉末弄朦在肯特紙上當底色，並試著用可揉捏橡皮擦出紙張的白底來作畫。比鉛筆底色濃的部分也可再加上鉛筆描繪。

Powdered graphite can be rubbed into a sheet of Kent paper to create a grey, mid-tone base. The white of the paper is then lifted out with a kneadable eraser and detail added to the light areas. Any tones darker than the base can be added using the pencil.

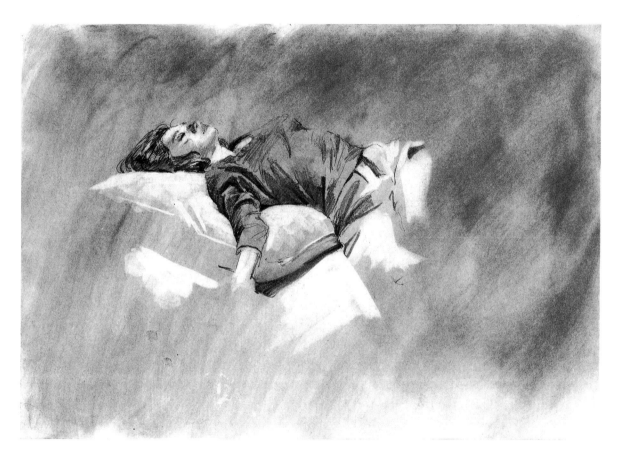

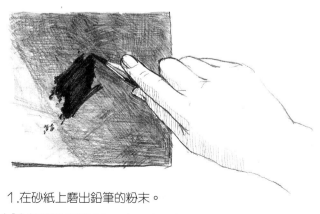

1.在砂紙上磨出鉛筆的粉末。

1. Rub the pencil against some sandpaper to create the graphite dust.

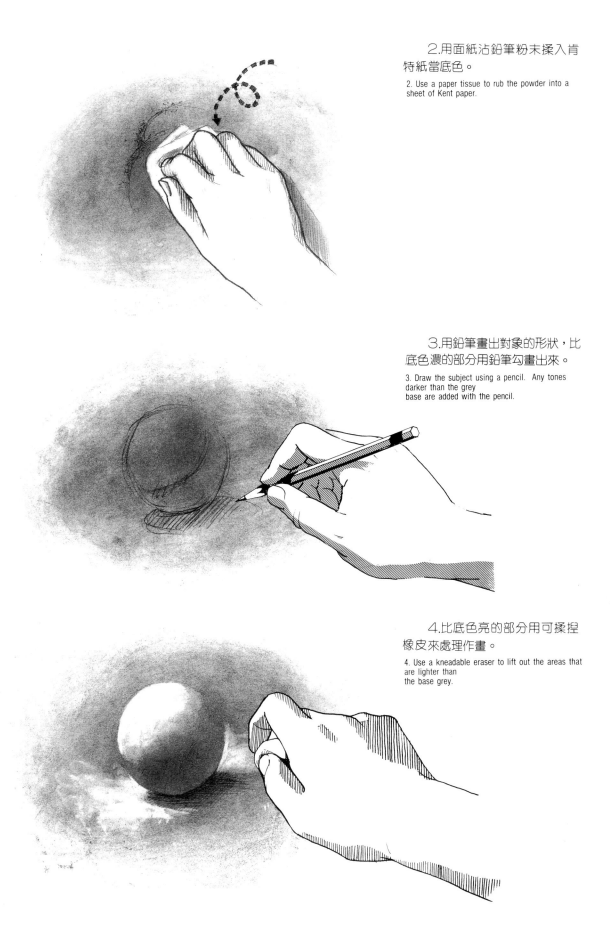

2.用面紙沾鉛筆粉末揉入肯特紙當底色。

2. Use a paper tissue to rub the powder into a sheet of Kent paper.

3.用鉛筆畫出對象的形狀，比底色濃的部分用鉛筆勾畫出來。

3. Draw the subject using a pencil. Any tones darker than the grey base are added with the pencil.

4.比底色亮的部分用可揉捏橡皮來處理作畫。

4. Use a kneadable eraser to lift out the areas that are lighter than the base grey.

用色紙素描
Drawing on Colored Paper

　　和用鉛筆在白紙上作畫的情況相反，它所要畫的
是明亮的部分，表現的效果完全不同。

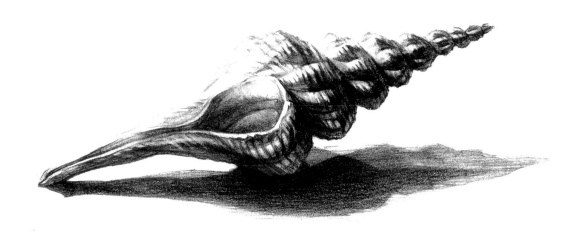

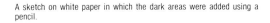

在白紙上用鉛筆畫出陰影的素描。

A sketch on white paper in which the dark areas were added using a pencil.

畫出陰暗的部分。

When using white paper, the dark areas must be drawn in.

利用中間色調或暗色調的紙來作畫時，必須使用比紙色調明亮的鉛筆，才能將題材突顯出來。

When drawing on mid-toned or dark colored paper, care should be taken that the subject stands up. For this purpose it is neseccary to use lighter colored pencil than the color of the paper.

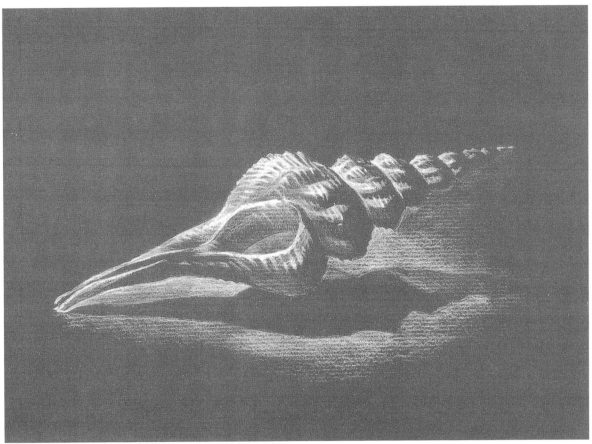

在色紙上用白色鉛筆畫出明亮部分的素描。

A sketch on colored paper in which the light areas were added using a white pencil.

畫出明亮的部分。

When using colored paper the light areas must be drawn in.

用白色鉛筆勾畫明亮的部分

　　勾勒出明亮的部分，色紙的顏色就不再只是陰影，同時也能表現出背景的空間。

Draw in the Light Areas Using a White Pencil

When drawing a backlit figure, using a white pencil to make it stand out, the color of the paper is used not only for the shadow areas but also for the background.

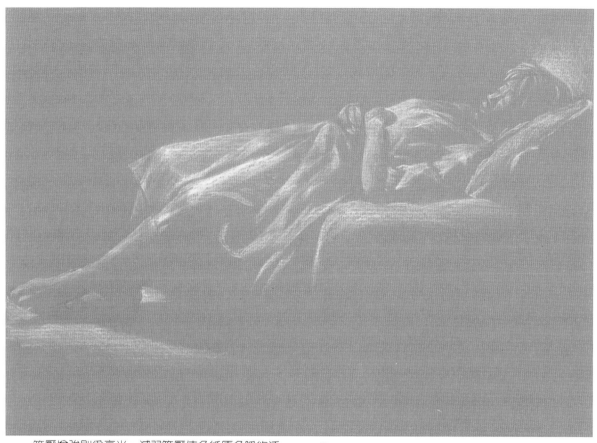

　　筆壓增強則為亮光，減弱筆壓使色紙原色隱約透出則可創造層次感。

Strong pressure on the pencil is used in the highlight areas while a gradation is achieved in the shadow areas by allowing the color of the paper to show through the white.

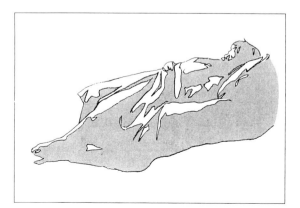

題材的明暗區分。

Divide the subject into areas of light and shade.

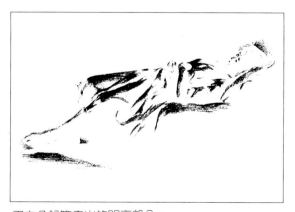

用白色鉛筆畫出的明亮部分。

Light areas to be drawn in with a white pencil.

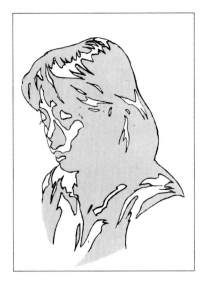 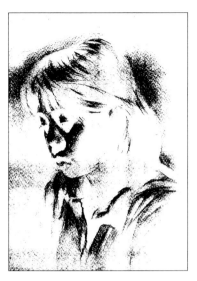

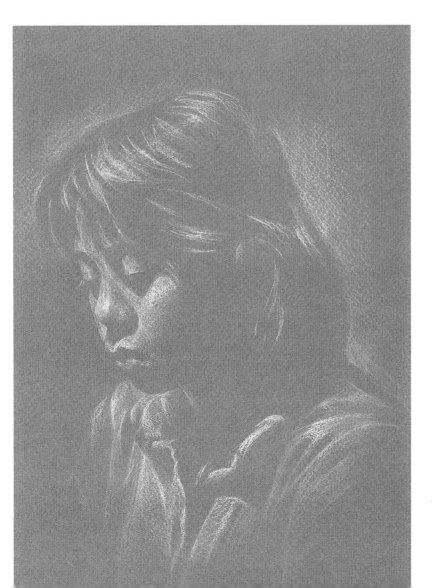

爲使頭的形狀明顯，背景就加
了淡淡的白色色調。

Add a faint white to the background to make the
head stand out.

用白色和黑色鉛筆素描
Drawing With Both Black and

在中間色調的色紙上，用白色鉛筆表現亮色，用黑色鉛筆表現暗色所畫出的足球。

明亮的色調大多是使用白色鉛筆，中間色調則是減弱白鉛筆筆壓所透出的色紙原色。暗色調是使用2B鉛筆。

A football drawn using three tones. The light tone is added using a white pencil, the mid-tone utilizes the color of the paper while the dark uses a black pencil.
The major portion of the light tones are added using a white pencil. The midtone utilizes the color of the paper by making a weaker pressure on the pencil. A 2B pencil is used for the dark tones.

足球的明中暗三種色調。明是白色鉛筆，中是色紙原色，暗是黑色鉛筆所畫出。

A football drawn using three tones. The light tone is added using a white pencil, the mid-tone is utilizes the color of the paper while the dark uses a black pencil.

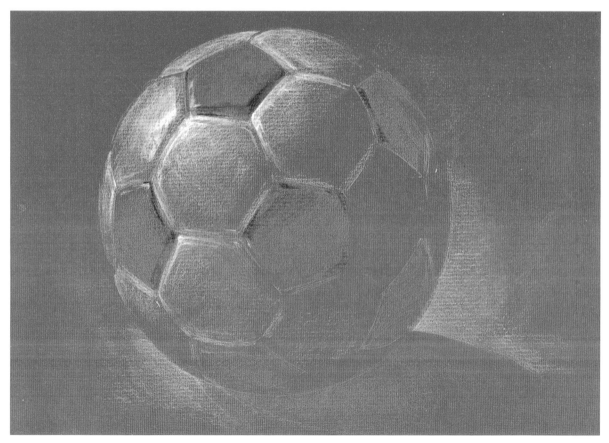

明亮的色調用白色鉛筆，深色調則用黑色鉛筆。

The light tones are added using a white pencil, while a black pencil is used for the dark tones.

透明感
Transparency

在鉛筆的深色調上用白色鉛筆製造亮光頗爲有
效。色紙則可作爲透明的玻璃器皿的背景色或金屬
色。

Strong lines are drawn with a white pencil to
create the highlights. The color of the paper can be
the background of the transparent glass ware and
the reflecting on the metal.

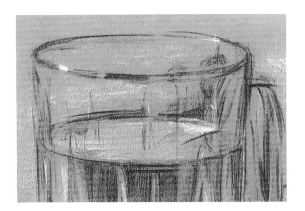

用色筆素描

要表現題材的陰影和背景的空間，可利用色紙的顏色。以接近題材固有色的色筆描繪向光的部分，將可充分感應被簡略的陰影部分。

Drawing With Colored Pencils

Try using the color of the paper for the shadows and background. If a colored pencil of the same color as the subject is used to draw in just the areas that are hit by the light the color of the paper will supply the abbreviated areas of shade.

向光的部分仔細描畫，其它部分則盡量簡略。

Concentrate only on the areas where the light falls and simplify the rest as far as possible.

以用紙之色調改變陰影表現
Alter the Expression of Shadow Through the Color of the Paper

側光：亮光使用白色鉛筆，陰影則使用一般鉛筆。

Side lighting : Use a white pencil for the highlights and a black pencil for the shadows.

　逆光：亮光用白色鉛筆，但陰影則是活用紙張本身的色彩。

Back lighting : The highlights are added using a white pencil, but the color of the paper is used for the shadow areas.

球體的反射

Reflections in a Sphere

其實並不難。不要擔心如何捕捉不銹鋼球體的質感，只要正確描繪出其所反映出的歪斜景物即可。只要有素描的基礎，再加上耐心就可以成功了。

There is nothing difficult about this. Do not worry about catching the texture of the stainless steel sphere, simply concentrate on recreating the distorted reflections accurately. If you have the basic sketching skills, it is just a question of patience to achieve a convincing result.

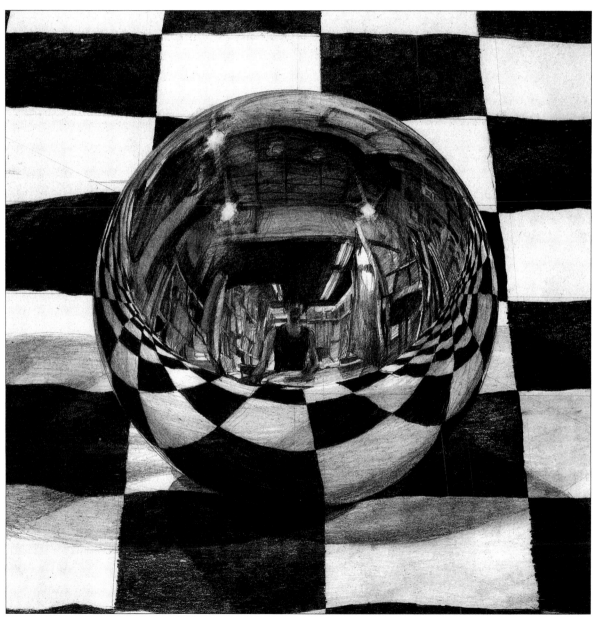

球體中明亮的灰色部分是用鉛筆將4H及HB的筆觸弄朦，而重要的部份則用2B小心描繪。桌中是使用4B及2B鉛筆。

The light grey tone in the reflection are created using a 4H and 4B then blended with a tortillon. The important areas are drawn carefully using a 2B. A 4B and 2B are used for the cloth the sphere is sitting on.

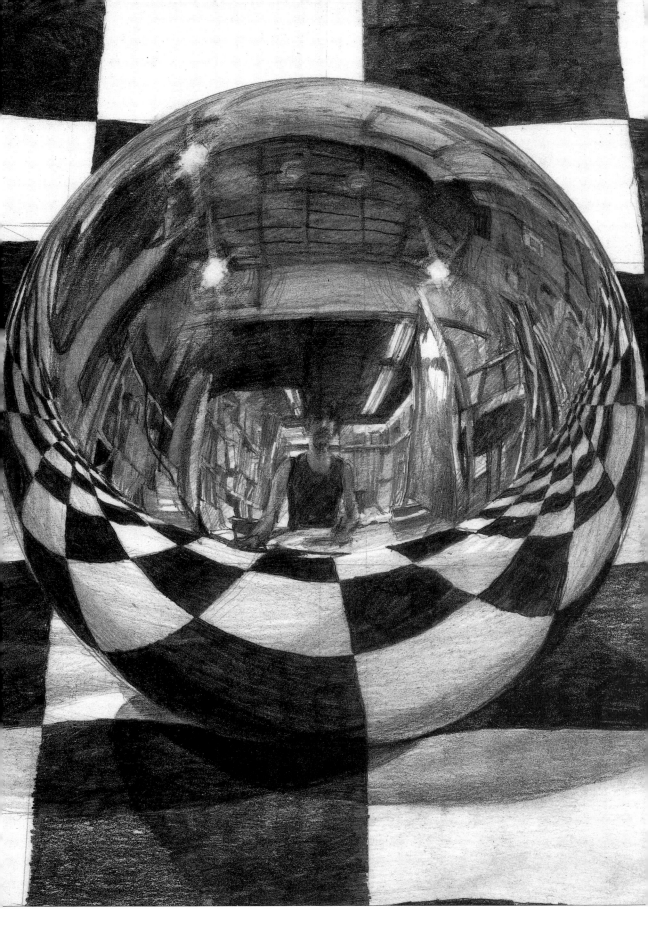

速寫
Rough Sketches

以線為主體,快速描繪。不必太重視形狀把重點放在對象的平衡感和線條的強弱上。可以只用大致的線條表現整體感,也可以加上若干陰影。只要有一支鉛筆和一本速寫簿,隨時隨地都可以速描。

Draw quickly using mostly lines. Do not worry too much about the shape, but focus on the balance and strength of the lines to recreate the feeling of the subject. A rough, overall feeling of the subject is fine although some light tonal expression is also acceptable. As long as you have a pencil and sketchbook, a rough sketch may be produced anywhere, at any time.

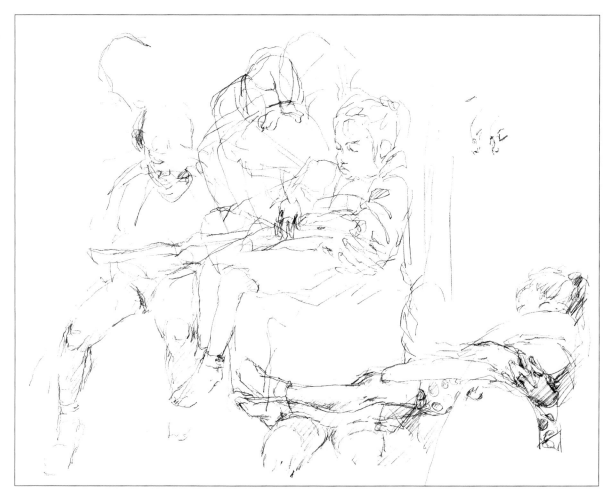

仔細觀察輪廓線的表情。

Study the expression in the outline.

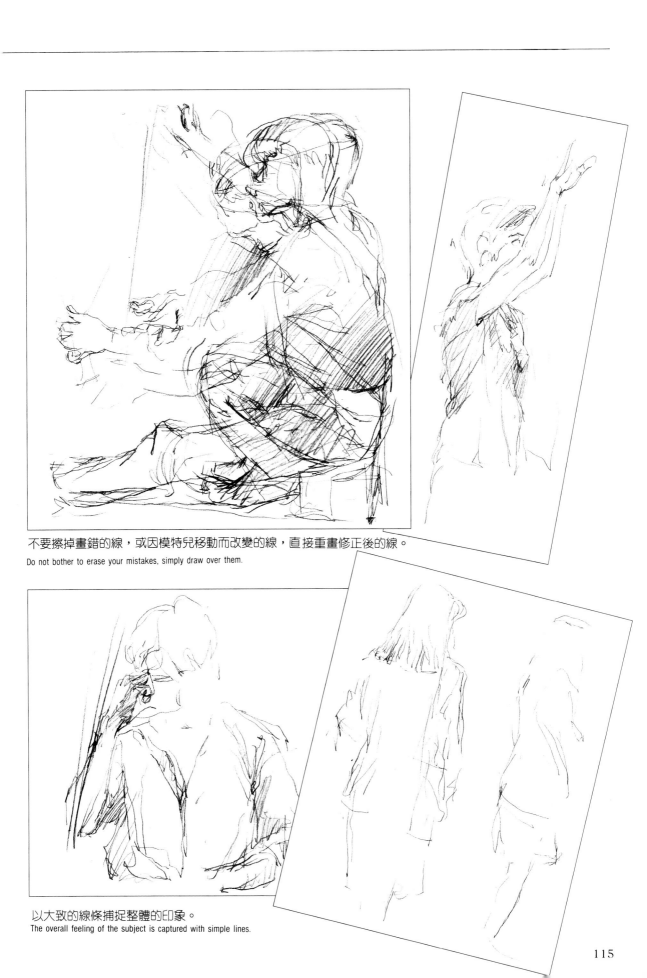

不要擦掉畫錯的線，或因模特兒移動而改變的線，直接重畫修正後的線。
Do not bother to erase your mistakes, simply draw over them.

以大致的線條捕捉整體的印象。
The overall feeling of the subject is captured with simple lines.

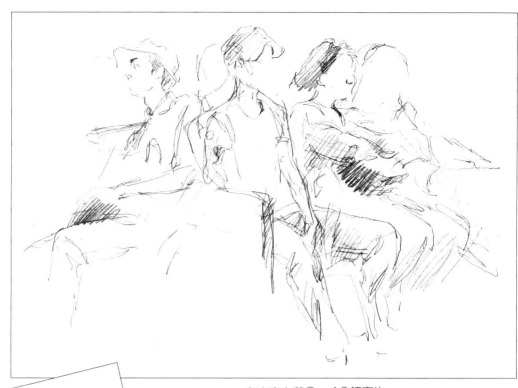

在火車上花3、4分鐘寫生。
Drawn in three or four minutes while sitting in a train.

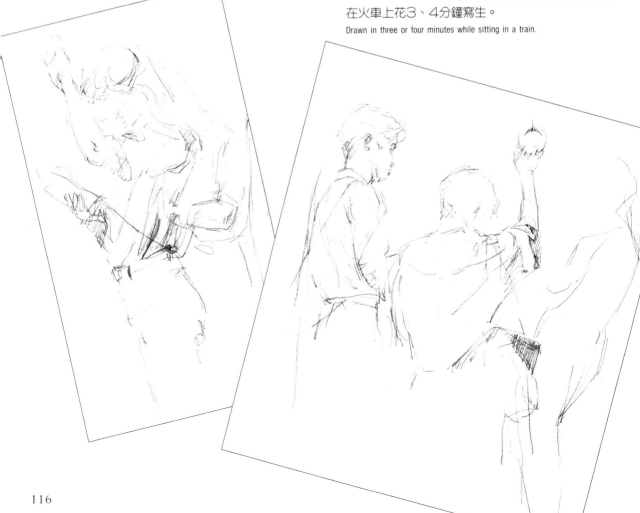

請模特兒擺好姿勢，用20分鐘把素描畫好。

Pose a model and draw her in approximately 20 minutes.

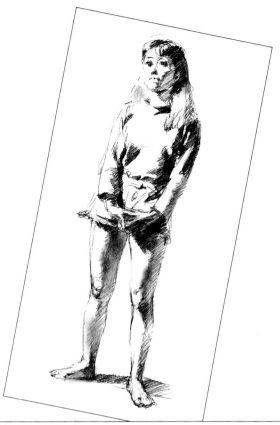

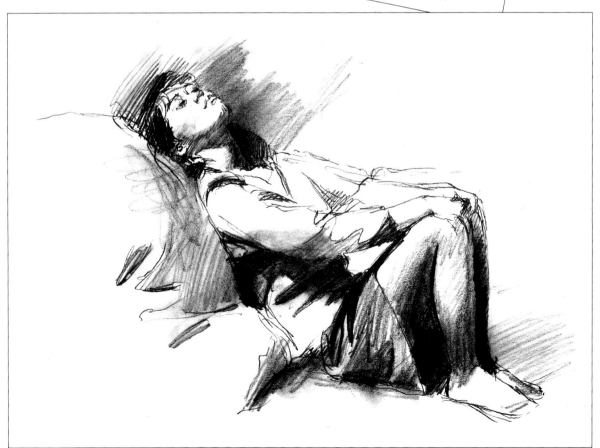

後記

Afterword

您知道我們平常隨手可得的鉛筆也有各種不同的
使用方式和表現方法嗎？希望透過本書的解說，您
可以學會基本的素描，表現出自我的天地。最後，
僅以十二萬分謝意，感謝福井歐夏、北川美帆兩位
先生對本書的參與協助。

I hope that you have now realized that the humble pencil
which we all take for granted can be used in a variety of
ways to create numerous effects. The aim of this book is to
teach the basic sketching techniques in order that you can go
out and capture your own world through drawing. Finally, I
would like to take this opportunity to thank *Ouka Fukui* and
Miho Kitagawa for their help without which I would not have
managed to produce this book.

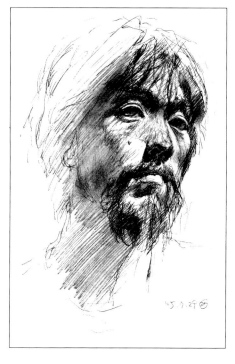

三澤寬志

1961年生於東京。

1983年起參加新創作協會展。

1985年取得武藏野美術大學碩士。

現爲武藏野美術學院講師。

Hiroshi Misawa
1961 : Born in Tokyo
1983 : Exhibited work in the Shinseisaku Association Exhibition
1983 : Graduated from Musashino University of Art
1985 : Completed a Masters course at the Musashino University of Art
At present working as a lecturer at the Musashino Academy of Art

鉛筆畫技法

定價：350元

出 版 者：新形象出版事業有限公司
負 責 人：陳偉賢
地　　址：台北縣中和市中正路322號8F之1
電　　話：29207133・29278446
F A X：29290713

編 著 者：三澤寬志
發 行 人：陳偉賢
總 策 劃：范一豪
美術設計：張斐萍、王碧瑜
美術企劃：張斐萍、王碧瑜、賴國平

總 代 理：北星圖書事業股份有限公司
地　　址：永和市中正路462號5F
門　　市：北星圖書事業股份有限公司
地　　址：永和中正路498號
電　　話：29229000（代表）
F A X：29229041
郵　　撥：0544500-7北星圖書帳戶
印 刷 所：皇甫彩藝印刷股份有限公司

行政院新聞局出版事業登記證／局版台業字第3928號
經濟部公司執／76建三辛字第214743號

國家圖書館出版品預行編目資料

鉛筆畫技法／三澤寬志原著，新形象出版公司
編輯部編譯. — 臺北縣中和市：新形象，民
85
　面；　　公分
ISBN 957-9679-00-2(精裝)

1.鉛筆畫

947.2　　　　　　　　　　　85007740

西元2007年1月